Flash

Flash

Derek Watkins

Focal Press
London & Boston

Focal Press
An imprint of the Butterworth Group
Principal offices in London, Boston, Durban, Singapore,
Sydney, Toronto and Wellington

British Library Cataloguing in Publication Data

Watkins, Derek
Flash.
1. Photography, Flash-light
I. Title
778.7'2 TR605

ISBN 0-240-51119-0

First published 1983

Series designed by Diana Allen
Book designed by Roger Kohn
Cover photograph by Derek Watkins
Photoset by Butterworths Litho Preparation Department
Origination by Adroit Photo Ltd Birmingham
Printed in Great Britain by Robert Stace Ltd,
Tunbridge Wells, Kent

Contents

Acknowledgements

I would like to thank Bowens Sales and Service Ltd., Laptech Photo Distributors Ltd., CZ Scientific Instruments Ltd., Bron Elektronik AG., and Philips Electrical Ltd. for their help in supplying information and illustrations for this book. I would also like to thank Paterson Products Ltd, distributors of Courtenay flash equipment, for loaning me equipment for use in producing the book. Finally, I would like to thank those companies who allowed me to use photographs taken for them. They are all acknowledged in the captions to the pictures.

Types of flash

At some time during their lifetimes, practically every photographer, whether amateur or professional, uses flash. It is one of the most widely used of all photographic accessories, yet at the same time it remains one of the most misunderstood. The first recorded use of any type of flash was as long ago as 1851 when Fox Talbot, inventor of the negative-positive system of photography, borrowed some equipment from his contemporary Faraday, the electrical pioneer, to demonstrate the use of an electrical spark as a photographic light source. The picture which Fox Talbot took was of a page from *The Times* newspaper attached to a wheel which was spinning; the flash of light was brief enough to arrest the motion of the wheel so that the type on the newspaper page could be read. In fact, not only was this the first recorded instance of a photographer using flash, it was also the precursor of what many think to have been a 20th century invention, electronic flash.

Unfortunately, the size and amount of the equipment necessary to produce the spark was so large that the system was not adopted as a popular photographic light source. Added to the problems of size and weight was the fact that the amount of light produced was very small anyway.

However, despite its disadvantages, some use was made of the electric spark for photography, mainly by scientists. In 1887, Ernst Mach, a professor at Prague University, succeeded in photographing bullets in flight at a speed of 765 m/h using the electric-spark method, and in 1892, Charles Vernon Boys of the Royal College of Science in London used the same method to freeze the motion of bullets piercing a sheet of plate glass at something approaching twice that speed. A. M. Worthington used the same method in 1908 to record splashes on the surface of liquids.

The equipment for flash photography has come a long way since those early days, and currently there are two main types of flash equipment available: flash bulbs and electronic flash units. The most important difference between these two types of equipment is that the electronic flash unit provides a large number of individual flashes from a single tube, while the flash bulb is expended in a single exposure. Electronic flash is the most popular type of flash unit with professional photographers and advanced amateurs, while the vast majority of expendable flash bulbs now used are in the form of flash cubes which are designed for use with Instamatic cameras.

Expendable flash bulbs

The history of the expendable flash bulb can be traced back to the 19th century when photographers were using magnesium flash powder as a source of a short but intense burst of light. By 1893 in France, a photographer called Chauffour was igniting magnesium ribbon with an electric current inside an oxygen-filled glass bulb. This was the forerunner of the modern flash bulb. However, it was not until 27 years later, in 1929, that Ostermeier made the first expendable flash bulbs on a commercial scale. Called the Vacublitz, this bulb used aluminium foil instead of magnesium as the combustible metal. Five years later, the Dutch company Philips introduced a range of flash bulbs using wire instead of foil, and later in that decade flash bulbs began to be used widely.

In appearance, an expendable flash bulb is rather like a domestic electric light bulb and, in the smaller sizes, it resembles a car headlamp bulb. The sealed glass envelope of the bulb is coated, both inside and out, with a cellulose lacquer to act as a safety device against the possibility of the glass shattering. This coating is either colourless for bulbs to be used with artificial-light colour film, or blue for taking photographs in colour with daylight-type film. In fact, all the smaller bulbs these days are coated blue. Inside the glass envelope is a filling of metal wire. Two types of metal are currently used for

flash bulbs, neither of which is the pure magnesium originally used for the very early bulbs. Large flash bulbs use an alloy of aluminium and magnesium, while the small types of bulbs used with portable on-camera flash guns are filled with zirconium. The bulb is filled with oxygen gas at a pressure rather lower than that of the atmosphere; this is a further safeguard against the bulb bursting and scattering flying glass.

There are three distinct stages in the firing of a flash bulb. As the electrical current is applied to the contacts of the bulb, a filament heats up which, when it reaches a sufficiently high temperature, ignites two small blobs of primer paste which explode and in turn ignite the metal filling of the bulb. The wire burns extremely rapidly to provide a brief but intense flash of light. As a further safety precaution, a small spot of cobalt chloride or similar materal is painted inside the bulb. This materal is normally blue, but if air leaks into the bulb as a result of cracks or faults in the sealing of the bulb, the spot changes colour to pink. This gives an instant and positive warning when a bulb is faulty; to use a bulb when air has leaked into the envelope could cause a small explosion which would, of course, be very dangerous indeed. For this reason it is advisable to inspect the indicator spot in every bulb before using it. If the spot has become pink, do not use the bulb.

Firing circuits

In the very simplest firing circuits for expendable flash bulbs, the bulb is connected to a small battery of between 3 and 30 volts by way of the synchronising cable which is connected to the camera. When the shutter release on the camera is pressed, a small switch inside the shutter mechanism closes to complete the circuit and the flash bulb is fired. There are, however, several disadvantages with this type of circuit. First, the amount of current passing through the shutter contacts is rather large and this can quickly lead to the contacts becoming burned and pitted with the result that they have to be replaced; a fairly

Page 7: flash enables good clear photographs of action subjects to be taken even in poor lighting conditions. *P. Chan.*

Five different circuits for firing expendable flash bulbs. (A) Basic circuit to fire bulb by connecting it direct to the battery. (B) Battery-capacitor circuit. Capacitor C charges slowly through resistor R and flash bulb B. When switch SW is closed, capacitor discharges through the bulb and fires it. (C) The same as 2 but with a test switch X which connects a test indicator T to show that both the bulb and the battery are in order. (D) Remote firing circuit controlled by a silicon-controlled rectifier (SCR). (E) Remote firing circuit controlled by a light-activated silicon-controlled rectifier (LASCR).

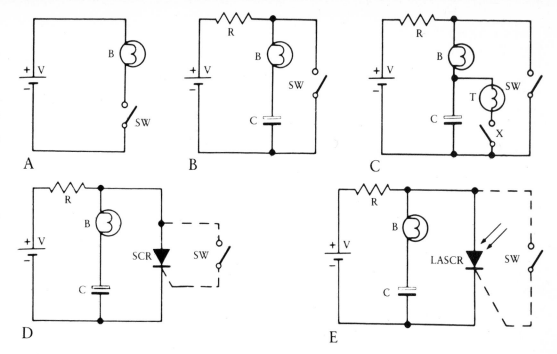

expensive exercise. Secondly, again because of the relatively high current flowing through the circuit, any bad connections or dirty contacts constitute a high resistance and can cause the bulb to fail to fire. And thirdly, once again because of the high currents involved, the batteries need to be fairly fresh to avoid the possibility of a misfire.

To overcome these problems, a different system of firing is now almost universally used. Called the battery-capacitor system, its main component is an electrolytic capacitor which is charged from the battery through the filament of the flash bulb and a current-limiting resistor. This resistor controls the current allowed to flow through the filament of the flash bulb to a value which is too low to fire the bulb. This system is less dependent on the condition of the battery; as the battery ages the capacitor simply takes longer to charge up. When it is fully charged, closing the shutter contacts in the camera causes the capacitor to discharge rapidly through the flash-bulb filament, so firing the bulb.

Although the battery-capacitor circuit is less dependent on the current the battery is capable of delivering, the discharge of the capacitor to fire the bulb still produces a fairly large current to flow through the shutter contacts in the camera; and this again, as with the simple battery system, can cause sparking and burning of the contacts. Several modern battery-capacitor flashguns therefore use a semiconductor device in the form of a silicon-controlled rectifier, or SCR, to carry the main current to fire the bulb and the only current carried by the camera contacts is a minute one which is necessary to trigger the semiconductor.

Many battery-capacitor flashguns incorporate a test circuit to verify that the filament inside the bulb is not broken. This test circuit consists simply of a small lamp connected in series with a switch across the capacitor. When the capacitor is charged, pressing the switch discharges it through the test lamp, so indicating that the filament in the flash bulb is unbroken. Of course, if the test lamp does

not light it indicates that the filament in the flash bulb may be broken and so the bulb will not fire when the shutter release on the camera is pressed.

Types of flash bulb

Expendable flash bulbs come in a variety of sizes and types. The physical size of the bulb is a good indication of its power and light output; the larger-output bulbs have a size and appearance similar to those of a domestic light bulb, but instead of the normal bayonet cap they are invariably fitted with a large Edison screw cap with a single centre contact. These large bulbs are intended for professional use and have a very large light output. The Philips PF100, for example, has an output of 95 000 lumen seconds and a peak intensity of more than 3½ million lumens. At the other end of the scale the tiny AG1B flash bulb, only about 40 mm tall and 12 mm wide, has an output of 7000 lumen seconds and a peak intensity of just over half a million lumens.

Apart from physical size and light output, expendable flash bulbs are available in several different classes, each identified by one or two letters. These classes indicate the speed at which the bulb reaches its full brightness. Obviously, because of the three stages each bulb has to go through before the wire inside it is burning, there is a certain delay between applying the firing current to the bulb and the light reaching full brightness. The different classes of bulb available allow, to some extent, the particular delay time to be chosen.

Class F bulbs These bulbs have a very short delay time of around 5 ms (milliseconds) and half-peak duration of 10–15 ms. Half-peak duration is a measure of the burning time of the lamp when it is producing usable light. The Class F bulb is now practically obsolete and the only one currently available is the SM which is a small bulb with a bayonet cap.

Class MF bulbs These are the most numerous bulbs currently available, with a delay of some

15 ms and a half-peak duration of about 13 ms. They are small, low-cost capless bulbs and a typical one is the PF1 or AG1.

Class M bulbs These are mostly professional bulbs with fairly large light output. They have a delay of about 20 ms and a half-peak duration of about the same. Typical Class M bulbs are the Press 25 and Type 2 made by Sylvania.

Class S bulbs The main characteristic of Class S bulbs is their extremely high light output of about 100 000 lumen seconds and their long delay to peak brightness of about 30 ms. These bulbs are also large professional types and have a half-peak duration of about 20 ms. Typical of the class is the PF100.

Class FP bulbs These are special focal-plane bulbs designed for use at all shutter speeds with cameras having focal-plane shutters, and for this reason they have a special long flash duration with a typical half-peak duration of 30–50 ms and a delay to peak brightness of about 35 ms. In fact, with FP-type bulbs the delay time to peak is often misleading. More useful is the delay to half-peak which is about 20 ms compared with about 11 ms for other types of bulb.

The class of bulb largely governs the shutter speed at which the flash can be used with the camera, and for this reason the type of bulb should be chosen with great care. For example, bulbs other than FP cannot successfully be used with focal-plane shutters as the output is not constant.

Electronic flash

Although the first photograph using a form of electronic flash as a light source was taken as long ago as 1851, it was not until the 1920s that electronic flash as we know it today began to be available in an easily-usable form. Mainly responsible for the development work in these early days was Dr. H. E. Edgerton of the Massachusetts Institute of Technology in the USA.

Near right: typical expendable flash bulb. Sealed glass bulb A with combustible metal foil or wire B in an oxygen atmosphere C. When current passes through lead-in wires G, ignitor filament D heats up and fires primer paste E to start metal foil burning, and produces a brief flash of light. Leakage indicator bead F gives warning of air leakage into bulb by changing colour.

Far right: comparison of light output of different types of flash bulb: MF, M, S, and FP.

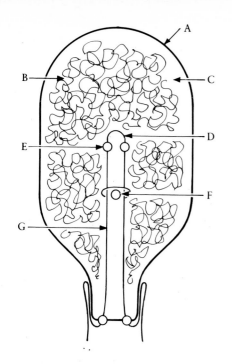

A

B

C

D

E

F

G

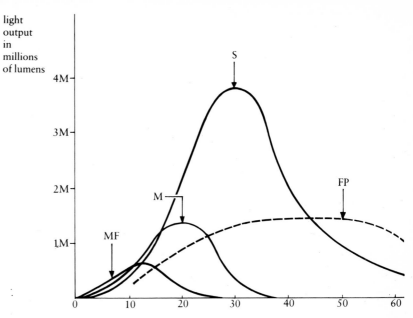

light
output
in
millions
of lumens

4M

3M

2M

1M

S

M

MF

FP

0 10 20 30 40 50 60

time in milliseconds after camera contacts close

Different flash bulb shapes.
Left to right: Edison screw
professional bulb; small
bayonet cap (SCC)
medium-power bulb;
miniature US centre cap
medium-to-low power
bulb; European capless
low-power bulb; American
capless low-power bulb.

The early equipment used by Fox Talbot and later scientific photographers needed a special high-voltage generating device called a Wimshurst Machine which had to be rotated at a fairly high speed by hand. The electricity produced was in the form of a static charge which then had to be stored in an instrument called a Leyden jar. This was a glass jar coated outside and inside with tin foil (which acted as electrodes), the electrical charge being stored in the dielectric or non-conducting glass. The principle of operation of the Leyden jar is very similar to that of modern electrical capacitors, and Edgerton replaced them with these modern capacitors. He also replaced the Wimshurst Machine with a transformer which enabled him to use the normal mains electricity supply as a source of power.

The spark which provided the light in the early flash experiments was simply produced by electricity jumping a gap between two wires. Edgerton found that he could produce a much brighter spark by enclosing the gap between the two wires in a sealed glass tube filled with an inert gas. What happens, in fact, is that when the spark is produced in the inert gas, the gas itself glows and increases the brightness of the flash. In Edgerton's experiment the gas used was neon, but in modern electronic flash units this has been replaced by another inert gas known as xenon.

Development work on electronic flash continued and just before the Second World War a commercial unit called the Kodatron was produced by the Eastman Kodak Company. As the world returned to normal after the war, professional and amateur photographers alike began to see the possibilities of electronic flash as a means of taking photographs in poor lighting conditions, and with the rapid development of electronic components generally in the 1950s and 1960s, great strides forward in both efficiency and miniaturisation were achieved. Today, small electronic flashguns scarcely larger than a packet of cigarettes are available with light outputs comparable with those from a large camera-mounted flash head combined with an even larger shoulder-hung power pack of just over 20 years ago. Added to this now are such advanced features as computer control of exposure and dedicated systems which work in conjunction with the exposure metering systems in certain automatic cameras.

How electronic flash works

Although electronic flash units have come a long way since Dr. Edgerton's early experiments, the principle of operation is still substantially the same. An electronic flash unit consists of several basic components. First of all there is some form of power supply. In most small units this consists of low-voltage batteries which drive a semi-conductor voltage-converting circuit to step up the voltage to several hundreds or even thousands of volts. In large studio units this job is usually done by a transformer which steps up the voltage from the normal a.c. mains supply. The high voltage produced by the converter circuit or transformer is rectified to d.c. current and fed to one or more large capacitors which store the energy produced. Connected to these capacitors is the flash tube. This is filled with xenon gas, and although it is connected directly across the capacitors, it will not conduct the current under normal conditions.

A triggering circuit, which is operated by the shutter contacts in the camera or by a separate switch, ionises the gas inside the flash tube and allows the current to flow from the capacitors to produce a spark inside the tube. The spark causes the xenon gas to glow, giving a very short but extremely intense flash of light lasting anything from 1/250 second to 1/100 000 second or even less. The flash tube is contained within a reflector which directs the light towards the subject with maximum efficiency.

The shape and size of the flash tube depends very largely on the working voltage of the unit and the power of the flash. The higher the voltage, the longer the tube. In high-powered studio flash units,

Three firing circuits for electronic flash. (A) A high-voltage charge stored in capacitor C is transferred direct to the flash tube by closing switch X. (B) Voltage stored in capacitor C is too low to fire the flash tube directly, but closing trigger switch SW discharges trigger capacitor CT to produce a high-voltage pulse from transformer T to induce ionisation in the tube via overwind wire TC. This causes the tube to fire. (C) A trigger sensitisation circuit reduces the current through the switch contacts.

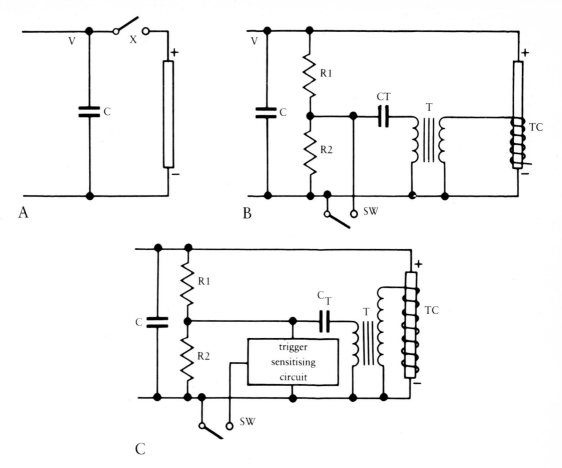

the tube is often left as a single straight length; but as this is obviously inconvenient in portable units, the tube is either folded into a U or formed into a coil. Again, in large studio units the tube may be enclosed in a glass outer envelope and fixed to a base with pins to enable it to be plugged into a socket. This, of course, makes it easy to change a tube in the case of a failure or breakage. One of the major advantages of electronic flash is that the spectral response of the light from the flash tube is very close to that of normal daylight: about 5500 to 6000°K. This means that normal daylight-type colour film can be used with electronic flash without the disadvantage of having to use conversion filters.

The way in which the power of an electronic flash unit is quoted depends largely on whether it is a portable unit or a large studio unit. With portable flashguns the power is usually quoted in the form of a guide number from which the correct aperture at any particular distance can be calculated, but in the

13

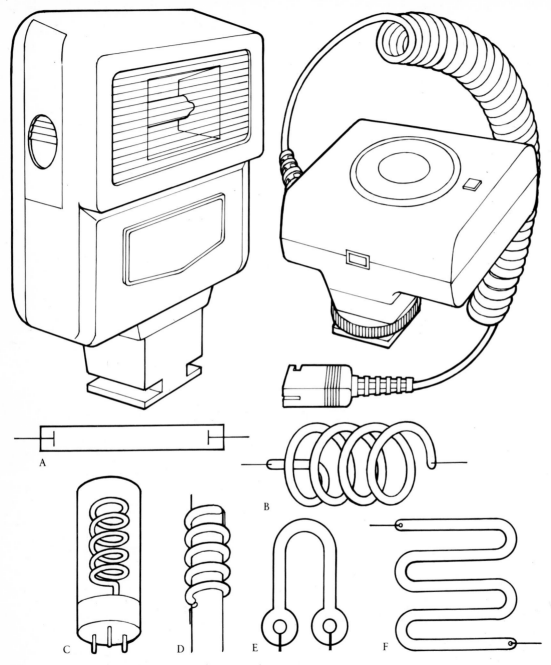

Far left: Sunpak SP140, a typical small camera-mounted electronic flash gun.

Near left: remote computer-controlled unit for use with Sunpak electronic flash units.

Below: electronic flash tube shapes. (A) straight, double-ended; (B) spiral, double-ended; (C) spiral, in glass envelope with mounting base and pins; (D) spiral, single-ended; (E) 'U', single-ended; (F) grid.

A

B

C

D

E

F

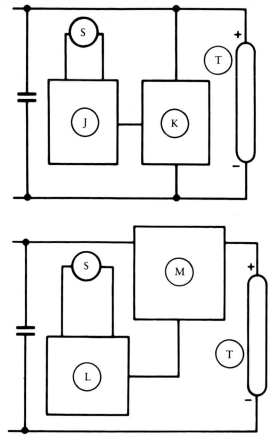

Computer-control circuits for electronic flash. Top: dump circuit. Light reflected from the subject falls on sensor S and is integrated by J until sufficient exposure has been given. Dump switch K then short-circuits the flash tube and cuts off the light. Above: blocking circuit. Integrator L is fed from sensor S holding switch M closed until exposure is complete, then M cuts off the voltage to the tube to terminate the flash.

case of the large studio unit it is more often given in the form of joules or watt-seconds. This is simply an indication of the amount of energy stored in the capacitor and thus available to produce the flash.

As an indication of the relative amounts of power available in different size units, small amateur portable units produce a power of somewhere between 25 and 100 joules, portable professional units produce between 100 and 1000 joules, and large professional studio units produce between 1000 and 20 000 joules output.

One of the disadvantages of electronic flash is that the amount of light produced tends to be very much less than that of a small expendable bulb. For example, a typical small amateur electronic flash gun produces something like 2000 lumen seconds, which is only just over a quarter of the amount of light produced by a small capless expendable flash bulb such as the AG1B. But the advantages of electronic flash tend to outweigh this slight disadvantage, especially with the comparatively high-speed films available today.

Electronic flash units have become so popular that the cost of a typical small amateur unit is now only slightly more than that of an expendable bulb unit. And once the unit has been purchased the running costs are extremely small; they are limited to the periodic replacement of batteries, whereas the running costs of an expendable bulb unit are fairly high, because flash bulbs are not cheap. To all intents and purposes, the life of the tube fitted to an electronic flashgun is indefinite; at least 10 000 flashes can be expected from a tube before it needs replacing and this can easily represent a lifetime of flash photography. The cost of 10 000 expendable flash bulbs, even the smallest and cheapest available, would be many times the cost of a small electronic flashgun.

Computer flash
The most interesting and useful development in the field of electronic flash in recent years is the

introduction of the so-called computer flash system. Until the advent of these computer units, the brightness and duration of the flash produced by the unit were both fixed. What the computer gun does is to control the length of the flash according to the amount of light reflected back from the subject. This means that the exposure is automatically controlled by the circuitry inside the flash unit.

The computer flash system uses an in-built photo-electric sensor which detects the light from the flash reflected from the subject. This is connected to an integrating circuit which in turn operates an electronic thyristor switch to cut off the voltage supply from the flash tube when enough light has been reflected from the subject. This, in effect, controls the duration of the flash, making it inversely proportional to the amount of light reflected. When a lot of light is reflected because the subject is very light in tone, or close to the camera and flash unit, the flash duration is very short. But when the subject is further away or much darker in tone, the flash duration is longer.

Early computer flash units used a 'dump' circuit to control the duration of the flash. In this type of unit, the flash is fired as normal and light reflected from the subject is picked up by the photo-electric sensor. When the amount of light received by the sensor reaches a preset level, the integrating circuit operates an electron-tube short-circuiting switch which instantaneously disperses any energy left in the capacitor, so cutting off the supply to the tube. This system works very well indeed but is rather wasteful of electrical energy and so a more efficient system was developed.

This alternative system is called a 'blocking' control. The light sensor and integrator circuits in this type of unit work in exactly the same way as the dump system, but when the light received by the sensor reaches the preset level the integrator circuit operates an electronic cut-off circuit which is connected between the capacitors and the tube. So

instead of the energy in the capacitor being dumped and wasted, it is retained ready for use in the next flash. This has two effects. In the first place it means that less power is required to charge the capacitor fully before the next flash, and this of course means a saving in battery life in small portable units. And secondly, it means that the charging time for the second flash is very much shorter than it would otherwise be.

The figures given in the specification of a typical computer flash unit – the Braun 370BVC – indicate a recycling time of 12 seconds when the unit is used at full power and as little as 0.2 second when the unit is used in the computer mode at the shortest flash duration time. The actual flash duration with this same model ranges from 1/330 second at full power to 1/15000 second in the computer mode at the shortest flash duration. The advantages of this computerised-control system are obvious. Once the camera has been set to the aperture required, the same aperture is set on the control scale of the flash unit, and pictures can then be taken at any distance. The computer control ensures that the film receives the correct exposure, irrespective of the distance of the flash from the subject.

Most computer-controlled flash units have an indication on the scale to show the maximum distance at which the computer control will operate at each aperture, and may also incorporate a simple test circuit which indicates whether the flash will be sufficiently powerful for a particular situation. To use this circuit, the open-flash button on the unit is pressed to fire the unit and, if there is enough light reflected from the subject, an indicating-lamp lights.

Flash synchronisation
In order to ensure that the flash fires at precisely the moment when the camera shutter is fully open, synchronising contacts are built into the shutter and are connected to a small socket on the front of the camera. This socket is, in turn, connected to the flash unit by a synchronising cable so that when the

A typical simple product photograph. This one was taken using a small portable flash unit directed at a large piece of white card above the subject to give soft lighting.

camera shutter is operated the contacts close and complete the circuit in the flash unit to fire the bulb or tube. Most cameras have two synchronising sockets marked M or FP and X. Or they may have a single socket and a lever marked M or FP and X. This is to enable the camera to be used with both expendable bulbs and electronic flash. The reason for the two sockets is that, while electronic flash reaches its full brightness almost instantaneously, flash bulbs take a few milliseconds to reach useful brightness. For this reason, expendable flash bulbs are fired a few milliseconds before the shutter actually opens, so that by the time the shutter is fully open, the bulb has reached its half-peak brightness.

M synchronisation is normally found on cameras with between-lens shutters and the shutter contacts are designed to close 15–20 ms before the shutter is fully open. By this time the flash bulb has reached its usable brightness. The delay enables M synchronised cameras to be used with all class M and MF bulbs at all shutter peeds, and class S bulbs can also be used at speeds not faster than 1/30 second. Cameras with FP synchronisation have focal-plane shutters which work in quite a different way. Instead of the whole negative area being exposed at one time in the camera, the focal-plane shutter exposes it in strips when set to speeds faster than 1/60 or 1/125 second. For this reason, special Class FP bulbs must be used. These have a long burning time rather than a short, sharp peak. Again, the shutter contacts close a few milliseconds before the shutter actually opens to enable the bulb to reach its useful light output before the shutter opens.

Electronic flash presents a slightly different problem. Because it reaches full brightness almost instantaneously, if it is used with M- or FP-type synchronisation the flash is over and done with before the shutter opens. So a separate X socket or switch position is built into most cameras. When the camera is used in this mode the contacts in the camera close when the shutter is fully open,

The effect of using too fast a shutter speed when using electronic flash with a focal-plane shutter. Left: shutter speed of 1/60 second on Olympus OM-1. Above: shutter speed of 1/125 second on Olympus OM-1 exposes only half the negative.

allowing the full amount of light from the flash unit to be used. The very short duration of the flash with electronic units creates a problem with cameras using focal-plane shutters. Because the flash duration is so short, an electronic unit can only be used at a shutter speed which uncovers the whole negative area of the film at the same time; in other words, speeds slower than 1/125 second or 1/60 second, depending on the specific camera. If a shutter speed faster than this is used, only part of the film is exposed and the picture does not extend to the full width of the frame.

Many cameras these days are fitted with a device called a hot shoe. The purpose of this is to hold an electronic flash unit on the camera and, through electrical contacts on the shoe and the foot of the unit, to synchronise the flash with the shutter. This enables the flash unit to be used without the inconvenience of a separate synchronising lead which may accidentally become disconnected from the camera. Some hot shoes also have additional contacts which enable the exposure metering device in some automatic cameras to be connected with the flash unit to give a much more sophisticated computer control of flash exposure.

Testing synchronisation
A simple way to test the X synchronisation of a camera with between-lens shutter is to fix a small piece of bromide paper in front of the lens with the emulsion side to the lens. Open the back of the camera and place the flash unit so that the head is pointing into the camera. Now connect the synchronising lead to the camera socket and press the shutter release. If the synchronisation is correct you should see a faint circle on the piece of bromide paper when it is removed from the front of the lens. If the shutter contacts are closing too early or too late, instead of a faint circle you will see see a faint star pattern. In this case the camera should be sent to a competent repairer to have the synchronisation checked electronically and, if necessary, adjusted. With focal-plane cameras, the small piece of bromide paper should be fixed inside the back of

the camera where the film normally goes, and the electronic flash head pointed towards the lens from in front of the camera. When the flash has been fired by pressing the shutter release, the bromide paper should show a faint rectangle the full size of the negative frame. If the darkening is smaller than the full negative area, a slower shutter speed should be used for electronic flash, and the test repeated at the next slower shutter speed.

Flash and exposure

One of the major problems with using flash as a light source for photography has always been that of establishing accurately the correct exposure required. Unlike other light sources, flash illumination is not continuous, and its duration is too short for it to be measured by a conventional exposure meter. However, special flash meters are now available which respond to the very brief flash of light and retain the reading until either a reset button is pressed or a predetermined period of time has elapsed. These flash meters are rather expensive and are designed primarily for professional use; they will be dealt with in some detail a little later.

One point about flash photography which many beginners find is that the shutter speed at which the camera is set has little or no effect on the resulting picture, unless a focal-plane shutter is being used at a high shutter speed, when only a part of the frame will be exposed. The reason is that the exposure time is determined by the duration of the flash. For example, if an electronic flash unit giving a flash duration of 1/1000 second is used, it matters little whether the camera is set to one second or 1/1000 second, since the exposure time given will be 1/1000 second in either case. So at any given subject distance, the only control available for exposure is the aperture used.

Some more advanced electronic flashguns, though, now have variable output controls, as do large studio flash units. This means that the power of the flash can be varied to enable a particular aperture to be used to control the depth of field in the shot. Expendable flash bulbs, on the the other hand, have a flash duration averaging about 1/30 second, so if a shutter speed faster than this is used a certain amount of light from the bulb is lost. So in this case the shutter speed used does have an effect on the exposure.

21

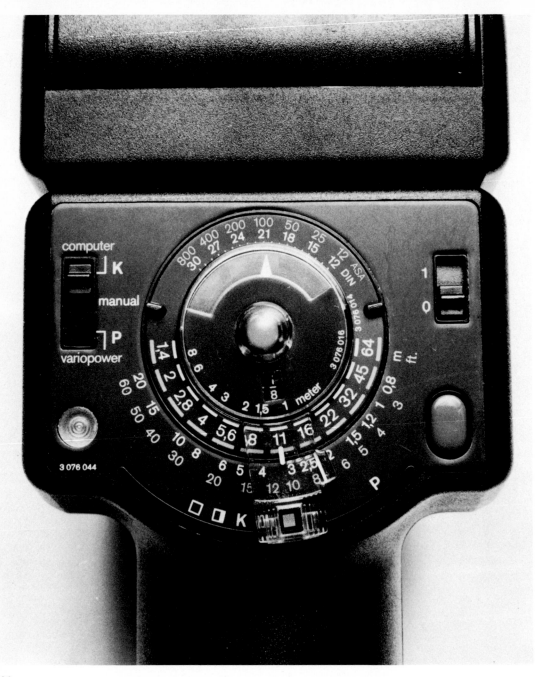

Page 20: flash lighting by direct flash is characterised by a sharp, crisp quality. *P. Rabey.*

Page 21: flash is useful for outdoor pictures in dark surroundings such as woods where large depth of field is required, as in this close-up shot. *Chris Howes.*

The calculators fitted to most modern electronic flashguns make exposure determination an easy matter.

Other factors which affect exposure with flash are much the same as those which affect exposure in normal photography: film speed, the brightness of the light falling on the subject (in this case the light from the flash tube or bulb itself) and the distance of the flash unit from the subject. (With outdoor photography, of course, this last factor does not apply because the light source is the sun which is 93 million miles away, thus remaining at a virtually fixed distance from the subject!)

Guide numbers

Although tables are often provided with flash bulbs and some electronic flashguns, the almost universal method used for calculating correct flash exposure is the guide number. Because a flash unit provides light of a constant brightness, the calculation of correct exposure is a simple matter. If the correct aperture to use at a specified flash-to-subject distance is known, it becomes easy to calculate the correct aperture to use for any other distance; and this is where the guide number comes in. Throughout this book, all calculations are carried out using metric guide numbers and distances in metres. Most manufacturers also give Imperial guide numbers for use with distances in feet. The use of these Imperial guide numbers follows exactly the method used for metric guide numbers.

The guide number is simply an expression of the flash distance and aperture which give a correctly-exposed negative or slide. To find the correct aperture to use at any distance, the guide number is simply divided by the distance, and the result is the aperture which should be used. For example, if the guide number is 33 with film of a particular speed, and the distance from the flash to the subject is 3 metres, the aperture to use for correct exposure is $33 \div 3 = f/11$; and if the flash distance is 1.5 m the correct aperture is $33 \div 1.5 = f/22$. And at a flash distance of 6 m, the correct aperture is $33 \div 6 = f/5.6$.

So when the distance is doubled, the exposure is increased by two stops; and when the distance is halved, the exposure is reduced by two stops, not one stop in each case as at first may be expected. This is because a difference in aperture of one stop normally halves or doubles the exposure, but when an artificial light source is used, be it flash or flood lighting, a phenomenon known as the inverse square law must be taken into account.

The inverse square law

The inverse square law states that when a surface is illuminated by a point-source of light, the intensity of illumination produced is inversely proportional to the square of the distance separating them. What this means in practice is that if the distance between the light source and the subject is doubled, the level of light at the subject is divided by two squared or four. By the same token, if the distance between the light source and the subject is halved, the level of illumination is increased by two squared or four. If the distance is increased by three times, the level of illumination is divided by three squared or nine.

The aperture on a camera works in a very similar way since it also obeys the inverse square law. It is a well-known fact that an aperture of $f/5.6$ allows half as much light to enter the camera as an aperture of $f/4$, but if the aperture *number* is doubled (in other words if the aperture is set to $f/8$), the amount of light entering the camera is divided by two squared or four. So because both the flash distance and the aperture obey the inverse square law, the guide number system works perfectly well at all distances.

Guide numbers and film speed

The guide number of a particular flash unit changes according to the speed of the film with which it is being used. Obviously, a higher-speed film is going to need a smaller aperture to give correct exposure at any given flash-to-subject distance. For example, a film with a speed of 400 ASA will only need half the exposure required by a film with a speed of 200 ASA. In other words, if the aperture required by the 200 ASA film were $f/8$, that required by the 400 ASA film will be $f/11$.

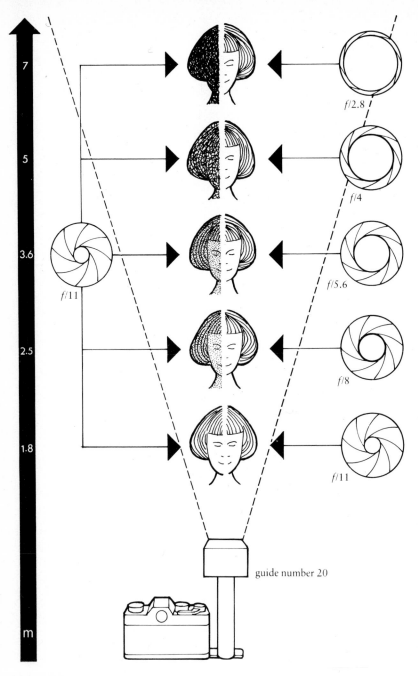

Light falling on a subject obeys the inverse square law; it decreases in inverse proportion to the square of the distance between the flash and the subject. The guide number given by the manufacturer takes this into consideration. For example, a guide number of 20 gives a shooting distance of 1.8 m at $f/11$ but at double the distance (3.6 m) an increase in exposure of two stops (four times) is indicated $(20/3.6 = f/5.6)$. If the aperture is left at $f/11$, the subject will receive only a quarter of the correct exposure.

guide number 20

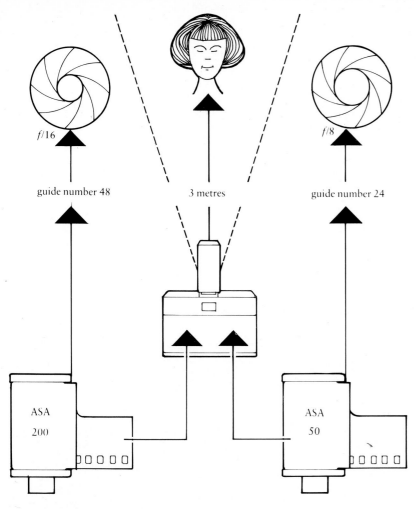

f/16

guide number 48

f/8

guide number 24

3 metres

ASA 200

ASA 50

The guide number varies according to the speed of the film in the camera. Dividing the guide number by the flash distance gives the aperture to be used.

Now, the difference between $f/8$ and $f/11$ is also based on a square law, but this time the inverse square root. $f/8$ allows twice the amount of light to enter the camera as $f/11$ but the f-number is not $f/11$ divided by 2, but $f/11$ divided by $\sqrt{2}$, which equals $f/11$ divided by 1.414. Because the aperture and guide number are linked, it follows from this that the guide number also obeys the square root law. So for a doubling of film speed, the guide number is multiplied by $\sqrt{2}$ and for a trebling of film speed, the guide number is multiplied by $\sqrt{3}$. For example, if a flash unit has a guide number of 38 for a film speed of 100 ASA it will be $38 \times \sqrt{2} = 54$ for a film speed of 200 ASA and $38 \times \sqrt{4} = 76$ for a film speed of 400 ASA.

As a general rule, then, if the guide number for a particular film speed is known, the guide number for any other film speed can be found by using the following formula:

$$N_y = N_x \sqrt{y/x}$$

where N_y = guide number with film y (unknown)
N_x = guide number with film x (known)
x = speed of film x
y = speed of film y

For example, if $N_x = 38$, $x = 100\,\text{ASA}$, $y = 250\,\text{ASA}$, $N_y = 38\,\sqrt{250/100} = 60$.

Guide number accuracy

The theory behind the use of guide numbers for the determination of flash exposure is a very sound one. In practice, however, guide numbers are not always as accurate as they might be, and the guide number for any flash unit will vary according to the type of subject being photographed and the conditions in which it is being photographed.

The guide number quoted for most flashguns is based on use in a medium-sized domestic room with fairly light-toned walls and ceiling, and as will be seen shortly, the guide number can be quite different when the flash is used in different situations.

The first thing to do, therefore, when you buy a new flash unit is to check the guide number quoted by the manfacturer. This can be done very easily. Set up a small still-life arrangement on a table in a medium-sized domestic room with light-toned walls and ceiling. Place the camera on a tripod at a distance of 1.5 m from the subject, carefully measured with a tape measure. From the guide number quoted by the manufacturer of the flash unit calculate the theoretically correct aperture at which to set the camera, and if the camera has a focal-plane shutter, set the shutter speed within the range recommended by the manufacturer for flash use.

Having set the correct shutter speed and aperture, make an exposure. Next, make another exposure with the lens aperture set half a stop wider than the theoretically correct one, and then another exposure at half a stop less than the calculated aperture. Repeat this procedure again, first with the lens set one full stop more and then with one stop less than the calculated aperture. Process the film using your normal technique, and if it is a negative film make prints from each of the five negatives. Select the print or slide which gives the best reproduction of the subject and check at which aperture that particular frame was exposed. To find the correct guide number for your flash unit, multiply the aperture at which the best result was obtained by 1.5 m. So if the aperture which gave the best result in your test was $f/16$, multiply 16 by 1.5 which gives 24, so the guide number for the particular flash unit being tested with the particular film used for the test is 24, and this may or may not coincide with the figure quoted by the flash unit manufacturer.

Flash exposure calculators
Most modern portable electronic flash units have a simple exposure calculator built in. The pointer is set to the speed of the film being used, and the

A small electronic flash unit makes an easily transported source of powerful light suitable for taking anywhere. *Chris Howes*.

correct aperture for any flash-to-subject distance is read off on a scale. This, of course, saves the trouble of calculating the correct aperture each time the flash is used and can save a lot of time and the possibility of mistakes. However, the calculator is based on the guide number specified by the flash manufacturer. So if tests prove this guide number is incorrect, the calculator too will be incorrect. However, even if this is the case, the remedy is quite simple.

Set the aperture which the tests showed to be the correct value against the 1.5 m mark on the calculator, and read off the film speed which should be set on the film speed scale of the calculator. In other words, if the tests carried out show the guide number to be too high, when the aperture found to be correct is set against the 1.5 m mark, the film-speed pointer will indicate a speed slower than that of the film in reality. For instance, if the test showed that the correct aperture at which the camera should be set when photographing a subject 1.5 m away is $f/11$ instead of $f/14$ (midway between $f/11$ and $f/16$) and the film in use is rated at 125 ASA, the film-speed pointer on the calculator should be set to 80 ASA instead of 125 ASA. This change in the ASA speed-setting on the flash unit remains constant over the whole range of film speeds, so if, for instance, a film of 400 ASA is being used the film speed on the calculator will be set to 250 ASA, and if a film with a speed of 64 ASA is used, the film-speed pointer on the flash unit will be set to 40 ASA.

Subject and exposure

The biggest problem with guide numbers is that they are designed for use in medium-sized rooms with light-toned walls and ceiling, so if the flash unit is used in any other situation the guide number no longer holds good and must be modified to avoid under- or overexposure. For example, if you are taking shots in a small room with completely white walls and ceiling, such as a modern kitchen, the guide number may have to be increased quite considerably because if the normal guide number is

used the negative or slide could be overexposed by as much as one stop. On the other hand, if the unit is being used in a large hall where the walls are much further away than they would be in a domestic room, or in a room which has dark walls, the guide number will be too high and may have to be reduced to avoid the film being underexposed by as much as two stops. The table below gives factors by which the guide number must be multiplied in order to correct it for different situations. The factors given should be treated as starting points for carrying out tests on the individual flash unit since the actual modification required largely depends on the efficiency of the reflector fitted to the flash unit. Many modern flashguns have adjustable reflectors so that they can be used with either standard or wide-angle lenses at maximum efficiency. These units normally have a different guide number for each of the reflector positions, and it must be remembered to use the correct one, to avoid incorrectly-exposed pictures.

Corrections to flash exposures

	bulb flash		electronic flash	
	reversal film	negative film	reversal film	negative film
medium-sized domestic room of medium tone	0	0	0	0
outdoors at night	+1 stop	+2 stops	+½ stop	+1½ stops
large halls, etc	+1 stop	+2 stops	+½ stop	+1½ stops
very large domestic rooms, or rooms with very dark walls and furnishings	+½ stop	+1½ stops	0 or +¼ stop	+1 stop
small, very light rooms	−1 stop	−1½ stops	−½ stop	−1 stop

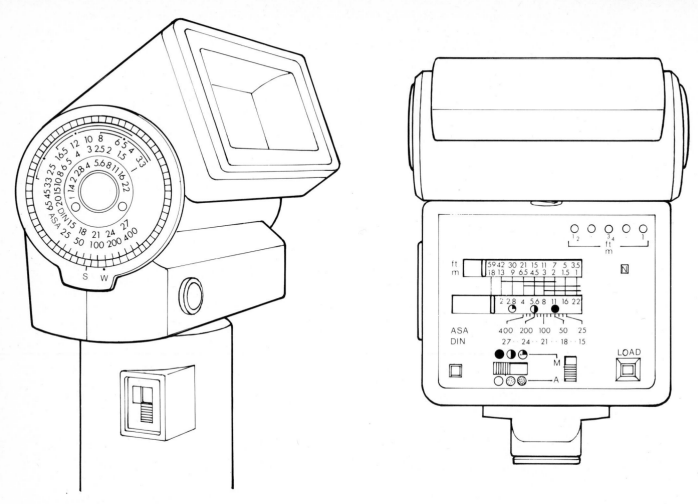

Another problem can be caused by the condition of the batteries in the flash unit. The guide number quoted by the manufacturer is, of course, based on the unit receiving a full charge from the batteries. However, if the batteries are run down, the capacitor inside the unit cannot receive its full charge and the light output from the flash tube is reduced. A small neon charge indicator is usually incorporated into electronic units to show when the unit is ready for firing, but this does not always indicate that the capacitor has received a full charge. The instruction booklet with the flash unit normally quotes a maximum allowable charging time for the unit, and if the charging time extends beyond this it is advisable to replace the batteries with new ones to avoid the possibility of underexposure resulting from only partly-charged capacitors.

How the subject affects exposure

On the face of it, it would appear that a dark-toned subject should receive more exposure than a

Left: Philips P32GTC computer-controlled electronic flash unit with standard and wide-angle lens positions (S and W) on the calculator dial.

Above: the calculator on a Philips P36CLT computer flash unit.

light-toned one. But this is not necessarily so. Consider, for example, a wedding group. If a photograph is taken of the bride, and then a similar shot is taken of the bridegroom, in the same lighting conditions, it is obvious that both should receive the same exposure. Yet if the rule of thumb is applied that says that a dark subject should receive more exposure than a light one, the exposure for the bridegroom may well be one or more stops more than that for the bride. But, of course, if this is carried out, the bridegroom's face is likely to be overexposed while the bride's face is underexposed. Either way, the two slides will look quite different when projected; or, if a negative film is used, the two negatives will require vastly different exposures to produce acceptable prints.

So when subjects other than so-called average are being photographed, it pays to apply a little thought before increasing or decreasing the exposure to allow for a dark or light subject. A small increase (say half a stop) is acceptable for a dark subject and will increase the detail in the shadows without overexposing the light tones too much. Similarly, a half-stop decrease in exposure is acceptable for a predominantly light-toned subject, and will increase detail in the light areas without causing the shadows to become clogged, solid black areas.

Exposure with computer flash

If manufacturers' advertisements are to be believed, computer flash units will automatically give the correct exposure in every case. But like all automatic-exposure devices, computer flash units do have their drawbacks. Because they control the exposure automatically, they are calibrated for so-called average subjects, just like the guide number for a non-automatic flash gun is arrived at; after all, they have to be calibrated on something and an average subject is perhaps the most logical choice. However, when a subject which departs from the average is being photographed, the computer-controlled circuitry can, and usually does, give less than perfect results.

The reason is fairly obvious. The unit works by a sensor in the flashgun receiving light reflected from the subject and cutting off the flash when the subject has received sufficient exposure. This means that when a light-toned subject is being photographed, the amount of light reflected from the subject will be more than if the subject was an average one, so the flash will be cut off before it should be. Conversely, if the subject is predominantly dark, the amount of light reflected from it will be less than from an average subject and the flash will be cut off later than it otherwise would be, resulting in overexposure. Fortunately, it is a simple matter to override the computer circuitry and fool the system into thinking that the subject is an average one.

Ensuring the correct exposure with a computer-controlled flashgun is simply a matter of setting the aperture required on the camera and then setting the scale on the flash unit to the same aperture. Since they are not linked mechanically they can be changed quite independently of each other, so the effective exposure can be increased or decreased at will. If the subject is a dark one which the computer flash would tend to overexpose, the aperture on the camera is simply set to half or one stop smaller than the aperture set on the flash unit, or alternatively, the aperture on the flash unit is set to half or one stop more than that on the camera. And if the subject is a predominantly light one which the computer unit would tend to underexpose, the aperture setting on the camera is set to half or one stop more than that on the flash unit, or the aperture setting on the flash unit is set to half or one stop less than that on the camera. Again, these are just guidelines which can be used as a basis for individual experiment.

Bounced flash exposure

One of the most frequently-used techniques in flash photography is to point the flash unit at a white wall or ceiling to soften its quality at the subject. Instead of the harsh black shadows often associated with flash, this technique produces soft, luminous

shadows which are much more flattering to most subjects and avoid the small but intensely black shadows produced by using direct flash. But if this technique is used, the normal guide number based on the distance between the camera and the subject does not apply. Instead, the distance between the flash unit and the reflecting surface, plus the distance between this surface and the subject, must be used to calculate the correct exposure. But because the reflecting surface tends to spread the light and partly absorb it, the calculated stop based on the total flash-to-subject distance must be increased to avoid underexposure. In most cases, an increase of one stop will be sufficient, but again this is simply a guideline upon which to base tests. This necessity to increase the calculated exposure also applies when using the flash unit in conjunction with one of the umbrella reflectors which have become so popular in recent years.

Bounce flash is another instance where computer-controlled flash units have come into their own. Most modern computer units have an adjustable head which can be pointed in virtually any direction while the body of the flash unit remains fixed. This means that the sensor, which is on the fixed part of the flash unit, always points towards the subject but the flash head can be directed at a wall, ceiling, or umbrella to provide soft bounce illumination. And because the sensor is still pointing towards the subject, it continues to receive the light reflected from the subject and produces a correctly-exposed negative or slide. Some of the early computer-controlled units, however, do not have this adjustable head feature, and if the flash unit is pointed towards a wall or ceiling to bounce the light, the sensor points towards this reflecting surface as well. In a case like this, the flash unit must be either switched to manual mode and the exposure calculated from the guide number, or the aperture selector on the flash unit must be set to three or four stops smaller than being used on the camera. This will cause the flash duration to be longer, which compensates for the high reflection from the wall or ceiling.

Dedicated flash

In 1976, Canon introduced their new AE-1 single lens reflex camera, and at a stroke simplified the use of electronic flash for ever. The AE-1 was the first camera designed to be used with a so-called dedicated flashgun. By fitting it to the hot shoe on top of the camera, it automatically eliminates the need for the shutter speed to be set to the correct value for electronic flash, the need to set the camera synchronisation to X, and the need to calculate the correct aperture at which to set the camera lens. Naturally, the introduction of the Canon AE-1 caused enormous interest in the photographic industry and it was not very long before other SLR manufacturers began to incorporate a dedicated flash system in their own cameras.

The flash unit for the AE-1 sets the shutter speed in the camera automatically to the correct synchronisation speed, selects the correct aperture to ensure proper exposure, sets the lens to this aperture when the shutter release is pressed, and illuminates a signal lamp in the viewfinder when the unit is ready to fire. What is more, once a flash shot has been taken, the camera automatically reverts to giving the correct exposure with the existing light until the flash unit is fully charged again.

This fully-automatic system is, of course, ideally suited to the flash photography undertaken by most amateurs, although it is rather limiting for the more adventurous photographer since the flash can only be used on the camera if full advantage of the automatic system is taken. But quite apart from any advantages to the user, the incorporation of dedicated flash systems has great advantages for the manufacturers. In the first place, it virtually forces the photographer to buy a flash unit made by the manufacturer of the camera, if he wants to take full advantage of the dedicated flash facility. These own-make flash units tend to be rather more expensive than those from independent manufacturers, and often have fewer features and less power into the bargain. And because there has

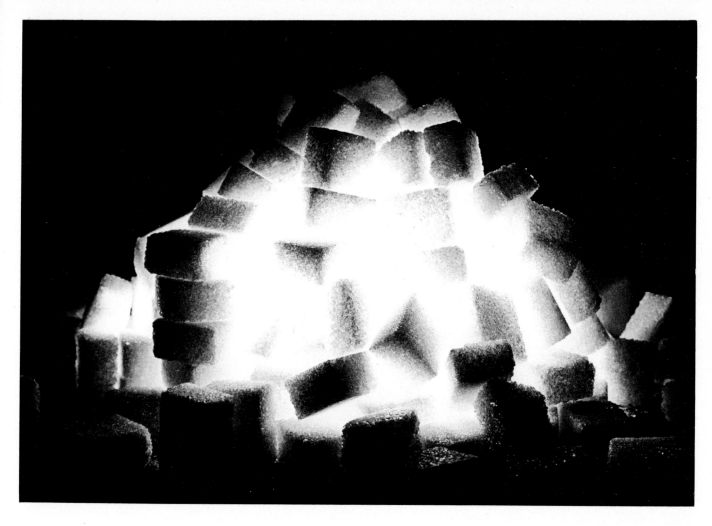

A pile of sugar cubes built round a small flash unit provides this fire-like result. *Henryk Kuglarz.*

been no co-operation between manufacturers to standardise on a particular system of operation or even contact layout in the hot shoe, there are at present more than a dozen different dedicated flash systems available for about two dozen different cameras. It is the same story as interchangeable lens systems all over again: every camera manufacturer wants to sell his own camera and flash, and make certain that flash units from other manufacturers cannot be used with his camera. In fact, in some

cases, if a flashgun from another manufacturer is used with a certain camera it can cause serious damage to the camera.

Because the circuitry of a dedicated flash unit and the circuitry of the camera with which it is used are electronically linked, it is more difficult to override the system to compensate for predominantly light or dark subjects. But it can be done. In the case of predominantly dark subjects where the exposure

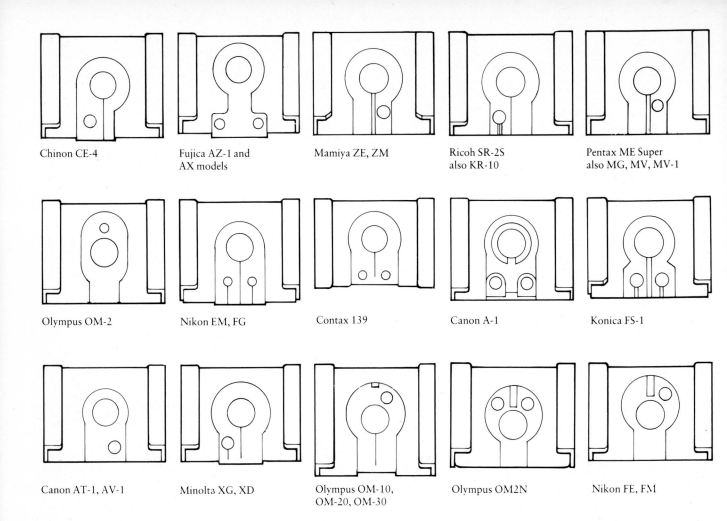

Chinon CE-4

Fujica AZ-1 and
AX models

Mamiya ZE, ZM

Ricoh SR-2S
also KR-10

Pentax ME Super
also MG, MV, MV-1

Olympus OM-2

Nikon EM, FG

Contax 139

Canon A-1

Konica FS-1

Canon AT-1, AV-1

Minolta XG, XD

Olympus OM-10,
OM-20, OM-30

Olympus OM2N

Nikon FE, FM

Some of the many different
contact arrangements in the
hot shoes for dedicated
flash units.

needs to be reduced from that which the automatic exposure system wants to give, the film speed control can be set to a higher value. And for predominantly light subjects where the exposure needs to be increased from that which the automatic system wants to give, the film speed should be reduced. This can often be done by using the exposure override control on the camera, but if the camera does not have one of these controls, changing the film speed as just described will have exactly the same effect. As a starting point for testing, try setting the control to double the speed of the film being used for predominantly dark subjects, and to half the speed of the film being used for predominantly light subjects. From the results it will be possible to tell whether more or less compensation than this is required.

While these dedicated electronic flash systems are undoubtedly very sophisticated, and remove yet another exposure problem from the photographer's shoulders, they do tend to be very restrictive. With all but a very few dedicated systems, the photographer is limited to using the flash unit attached to the hot shoe on top of the camera if the fully-automatic mode of operation is required. As soon as the flash unit is removed from the hot shoe to be used off the camera, the dedicated, fully-automatic facility is lost and the flashgun reverts to being a normal manual device.

When this is added to the restriction of having to use the camera manufacturer's own flash unit, which is invariably a fairly low-power device, it can be seen that in most cases a good computer-controlled flashgun with a fairly high light output is a much more versatile piece of equipment. Not only can it be used over a greater range of distances, but it can also be used easily off the camera, for bounced flash applications and to give lighting which produces better modelling; and the light output can be controlled easily without having to resort to such devices as changing the setting of the film-speed control on the camera, with the attendant risk of forgetting to reset it afterwards.

Guide numbers for multiple flash

In many cases, more than one flash unit may be used to illuminate the subject, and this naturally provides a higher level of light at the subject. So the guide number for any one of the flash units no longer applies. Instead, an effective guide number for the combination of flash units must be calculated. There are two ways of doing this. First, if all the units are used from the same distance, the effective guide number is equal to the square root o the sum of each of the individual guide numbers squared. In other words,

$$N_e = \sqrt{N_1^2 + N_2^2 + N_3^2 + N_4^2 + \ldots}$$

For example, assume that six flash units are being used with guide numbers of 33, 38, 24, 30, 48 and 33 respectively. The equivalent guide number for all these flashguns will be:

$$N_e = \sqrt{33^2 + 38^2 + 24^2 + 30^2 + 48^2 + 33^2}$$
$$= \sqrt{7402} = 86$$

The second method is a little more complicated, and is useful only if the individual flash units are used at different distances from the subject. Here, the first step is to calculate the correct aperture which each individual flash unit requires using the guide numbers in the normal way. Using the same flash units used in the example above at distances of 3 m, 2.5 m, 3.6 m, 2.7 m, 3.5 m and 4.25 m respectively, the correct aperture at which to use each of these units is $f/11$, $f/16$, $f/7$, $f/11$, $f/14$, and $f/9$ respectively.

Now for the second stage of the calculation, which is to work out the correct aperture at which to set the camera when using all these units together. This is calculated by taking the square root of the sum of each of the individual apertures squared. In other words,

$$A_e = \sqrt{A_1^2 + A_2^2 + A_3^2 + A_4^2 + \ldots}$$

So in the example,

$$A_e = \sqrt{11^2 + 16^2 + 7^2 + 11^2 + 14^2 + 9^2}$$
$$= \sqrt{824} = f/28$$

the correct aperture to use is a point midway between *f*/22 and *f*/32.

Both of these methods of calculation are based on the assumption that all the flash units are pointing towards the subject from roughly the same direction (more or less from the camera position) and are being used simply to provide a higher level of illumination than can be obtained using a single flash unit. If, however, the flash units are being used from different directions, to give modelling effects on the subject, this system of exposure calculation will not work so effectively. In fact, in most cases the exposure can be based on the guide number of the main flash unit only, since the other units are generally used simply to control the contrast by filling in shadows, providing back-lighting to give a halo effect around the hair, or for lighting the background, and have little effect on the overall intensity of the light. However, it may be worth carrying out a few tests for future reference, and a good starting point is to use the aperture calculated from just the guide number of the main flash unit, and then make a series of exposures at half-stop intervals less than the starting aperture.

Flash meters

In recent years, studio lighting has undergone something of a revolution, with tungsten floodlighting being replaced by large electronic flash units in many professional studios. Because of the problems of calculating the correct exposure accurately enough to avoid wastage of expensive large-format colour film, several flash meters have appeared on the market. Superficially, many of these look just like ordinary conventional exposure meters but their method of operation is quite different.

The problem with measuring the brightness of flash illumination is that the duration of the flash, especially electronic flash, is extremely short and the response of a conventional exposure meter is far too slow to record it, even if the indication on the

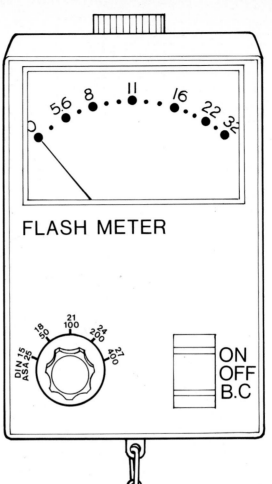

A simple flash meter by Polysales.

meter could be read in such a short space of time. So the basic requirement of a flash meter is that once the sensor in the meter has received the light, it must convert it to an electrical signal which must then be retained by the meter long enough for the indication to be read.

When the flash of light is received by the sensor, the resistance of the sensor drops and then rises again as the flash dies away. This produces, in effect, an electrical pulse which is fed into an amplifying

circuit at the output of which is a storage capacitor. This capacitor charges up to the voltage of the output pulse from the amplifying circuit and retains this charge. Also connected to the capacitor is a device called a field effect transistor (which is known as an FET for short) with a very high input resistance, which means that it does not discharge the storage capacitor.

Connected to the other side of the FET is a very sensitive meter which measures the voltage at the output of the FET. This voltage is proportional to that in the storage capacitor, and this in turn is proportional to the brightness of the flash. The storage capacitor retains its charge and the meter therefore continues to indicate until a reset button is pressed, which short-circuits the capacitor to get rid of its charge. The meter is then ready to take another reading.

Specific flash meters may work in a slightly different way from this but the principle remains the same in all of them. Like all electronic instruments, flash meters tended to be very expensive indeed when they first appeared on the market, but with increasing popularity and the lower cost of integrated circuits and microprocessors, these meters have gradually become less expensive over the years and can now be purchased at a very reasonable cost.

On portable computer-controlled flashguns, the job of the flash meter is effectively taken care of by the computer circuitry, and for small non-computer guns the guide number is generally accurate enough. But the flash meter really comes into its own when using more powerful studio flash units for portraits, advertising photographs and still-life set-ups. Most of the flash meters available work on the incident-light principle; in other words the meter is held at the subject position and pointed towards the camera. The light sensor is positioned behind a translucent dome which collects light from all directions, integrates it, and feeds it into the sensor.

This method of exposure determination is generally accepted as being the most suitable for reversal colour work – slides and large-format transparencies – because it avoids the possibility of overexposed and burned-out highlights which are disastrous for this type of colour work. However, there are some flash meters available, notably the Calumet, which offer a reflected-light reading facility as well. This is particularly useful when using more than one flash unit to control the contrast of the subject. Readings can be taken from the highlight and shadow areas, and the brightness or distance of the fill-in unit can be adjusted until the lighting ratio is controlled to the required level.

Most flash meters have a cable to connect them to the electronic flash unit. This is simply a convenience so that the flash can be fired from the subject position by simply pressing a button on the flash meter. Without this cable the flash meter has to be set up at the subject position and then the user has to return to the flash unit to press the firing button; some meters are designed to be used in this way. On balance, the type of meter with a triggering cable is probably the better choice of the two.

Simple lighting techniques

Virtually all small- and medium-format cameras designed to be used as hand cameras are fitted with some form of shoe to take the foot of a small flash unit. When the flash unit is attached to the camera in this way the combination makes a compact and complete system for taking pictures in poor lighting conditions. Yet it is surprising how many people think that, because a flash shoe is built into the camera, this is the only position in which a flashgun can be used. In actual fact, it is probably the least satisfactory position of all for taking pictures unless only a simple record of an event is required (in which case the quality of the lighting is not important as long as it is bright enough).

Flash on the camera

If mounting the flash unit on the camera provides the least satisfactory form of lighting, why do so many manufacturers fit a flash shoe to the camera in the first place? The answer is simple. For the large majority of photographers, the only time they use a flash unit is when they want to take snapshots at a party, a wedding, at Christmas, or some similar event, and in such cases the quality of the light is less important than its brightness. By fitting the flash unit to the camera, the two become a convenient package to use for snapshooting. The camera and flashgun are usually used in this way, too, by press photographers whose job it is to get a picture the content of which is far more important than the quality of the lighting. The main disadvantage is that the lighting produced is very flat and virtually shadowless, giving any person photographed in this way a haunted, 'staring' appearance. Any shadows that are produced tend to be very small and intensely black; altogether not a very flattering form of lighting.

If the distance between the tube or bulb and the camera lens is very small (as is the case with some

Instamatic cameras) another problem raises its head. This is a phenomenon known as 'red-eye' in which a person being photographed appears to have brilliant red shining eyes instead of their normal colour. It looks quite startling the first time it is seen, but the explanation is quite simple. Light from the flash unit enters the subject's eyes, which are often fairly dilated due to the frequently low level of ambient light, is reflected from the retina of the eye back out again and into the camera lens. So what the camera photographs in fact is the brightly-lit retina of the eye, and this gives the bright red shining appearance. Fortunately, this is solved simply by moving the flash unit slightly further away from the axis of the lens; many pocket Instamatic cameras (which are particularly prone to the trouble) are now supplied with an extension stalk on which to sit the flash cube. This increases the distance between the flash bulb and the camera lens by about 5 cm which is sufficient to overcome the problem of red-eye.

However, let us return for a moment to the problem of small and intensely black shadows produced by a flash unit fixed to the camera. The first problem that arises is the shadow of the subject on the background. Because the lighting is coming from the same position as the camera, the subject is surrounded by a small, very dark shadow on the background which can give quite an ugly effect. If the background is taken slightly further away from the sitter, the shadow becomes slightly lighter but very much bigger, and the overall effect is often very much worse.

Fortunately, there are one or two methods which can be used to overcome the problem and yet still retain the convenience of the flash mounted on the camera. The first solution to this problem of shadows on the background is probably the easiest. It involves simply moving the subject considerably further away from the background so that the background is at least two metres behind the subject. In this case, assuming that the flash unit is mounted on top of the camera, the shadow of the subject will fall below the level of the bottom of the picture area and so will not appear in the picture. If the flashgun is mounted to one side of the camera rather than on top of it, the shadow will fall outside the picture area to the left or right. Either way, the problem of the shadow on the background will be solved.

However, this method does raise two other problems, the first of which is one of space. Assuming that the photograph being taken is a head-and-shoulders portrait, and a longer than normal focal-length lens is being used to avoid distortion of the features, it can be seen that quite a long room is necessary to create a comfortable working area. First of all there is the distance between the background and the subject which, as we have just seen, needs to be at least two metres.

Then there is the distance between the subject and the camera which, with a long focal-length lens, again needs to be at least two metres. It is then necessary to have a certain amount of room behind the camera to allow the photographer to move about comfortably without the danger of knocking the tripod over – say another two metres for comfort. This means that the total length of the room or studio needs to be at least six metres.

The second problem raised by this method is that of background tone. Assuming that the relative positions of the camera, subject and background are as given in the example above, it can be seen that applying the inverse square law to the level of light from the flash unit, the tone of the background will be considerably darker in the photograph than it is in actuality. The distance from the camera and flash unit to the subject is two metres and from the flash unit to the background it is four metres. So the level of light at the background will be only a quarter of that at the subject. Assuming that the aperture used to take the picture is calculated to give correct exposure to the subject, the background will be, in effect, underexposed by two stops. This means that even if

Page 36: a close-up flash shot. The chart on page 139 is useful for close-up exposure calculations. *Paul Broadbent.*

Page 37: electronic flash has a very short duration, which freezes action.

the background is a plain white wall, it will appear in the photograph only slightly lighter than a middle-grey tone. Unless you use a second flash unit to light the background (as explained later in this book), there is no way around this problem.

Perhaps a better way of getting rid of the shadow on the background is to create a black background rather than using a white or light-toned background. This is also quite a simple matter. Instead of posing your subject in front of a plain light-coloured wall, use an open doorway into a darkened room as the background. Providing that there are no objects just inside the room which will be lit by the flash, the result should be a completely black background, because the light level at the wall will be so low that the wall will not register on the film. Or if it does, it will be as an extremely dark tone which can easily be burned in during printing. This method solves the problem of shadows on the background completely because the shadow cast by the subject is totally lost in the general darkness of the room used as a background.

The third method is a little more difficult but is capable of providing much more interesting results. Pose the subject against an open outside door or window so that the view outside forms the background for the picture. Again, this solves the problem of shadows on the background completely because the shadow falls on 'open air', as it were. It is, however, very important to calculate the exposure correctly if the result is to appear at all natural. It is far too easy, for example, to calculate the correct exposure for the flash and let the outside background take care of itself. However, this can lead to a grossly over- or underexposed background which looks quite unnatural. The ideal balance is to have the outside scene slightly overexposed. The reason for this is that for a correctly exposed picture of a person in a doorway taken by natural light, the background would be very much overexposed and the viewer expects this. So if both the subject and the outside background are perfectly exposed and picture looks unnatural.

The ideal solution is to take an exposure reading for the background and set the combination of shutter speed and aperture on the camera which will overexpose the background by about one stop. It is, of course, important to choose the shutter speed on the camera which allows the flash to be properly synchronised. Now calculate the flash-to-subject distance to give correct exposure to the subject. This is the distance from which you must shoot to obtain a properly balanced picture. A computer-flash unit is ideal for this method of shooting, because once you have established the correct aperture to use for the background exposure, you can simply set the computer scale to the same aperture and shoot from whatever distance you wish and still be assured of a perfectly exposed picture. This method of shooting is very similar to sychro-sunlight where the flash unit is used as a fill-in to lighten the shadows on pictures taken in bright sunlight. This technique is covered fully in the chapter on synchro-sunlight.

Off-camera flash
Generally speaking, the results obtained with the flash gun attached to the top or to one side of the camera tend to look rather artificial, and a distinct improvement can be obtained by just removing the flash unit from the camera and setting it up above and to one side of the camera.

Before a flash unit can be used off the camera it must be fitted with a long synchronising cable which can be plugged into the synchronising socket on the camera. Many of the larger and more powerful of the portable flash units available these days are supplied with a short plug-in synchronising lead, but a longer one can purchased as an accessory. However, many of the smaller and less expensive units have a fixed synchronising lead which is quite short. If this is the type of unit being used, a special extension cable must be obtained to provide the extra length of lead between the camera and the unit. These cables are available in a variety of lengths ranging from about one metre up to five metres or more. They consist of a length of thin

cable with a male co-axial socket at one end and a female socket at the other. One end of the cable is plugged into the camera socket and the other end into the plug on the short synchronising cable fixed to the flash unit. This enables the flash unit to be used at a distance of up to five metres or more from the camera, and allows much more interesting and adventurous lighting arrangements to be used.

Unfortunately, it is not always quite this easy with some cameras. Many modern cameras are fitted only with a hot shoe synchronising device which means that the flash unit must be used on the camera, fitted into the hot shoe. However, one or two independent accessory companies have produced small adaptors which fit into the hot shoe on the camera and have standard coaxial synchronising sockets fitted to them. One of these adaptors enables the synchronising lead from the flash unit to be plugged in so that the flash unit can be used remote from the camera. No adaptors of this type are available, however, for dedicated flash units which allow the fully-automatic operation to be retained; dedicated flashguns used in this way revert to normal manual units.

Fixing the flash unit

While it is quite possible to hold the camera in one hand and the flash unit at arms length in the other to take shots with remote flash, it is, in many ways, very limiting because you do not have a free hand to be able to change the settings on the camera. So this method is really only suitable for capturing pictures by the snapshot method; press photographers use this system all the time. It is ideal for use with a computer-controlled flash unit because the aperture on the camera can be set and the flash will give the correct exposure irrespective of the distance.

But if more controlled lighting is required and the picture is being taken in (say) a studio or the home, it is much better to be able to set up the flash unit on a stand of some sort because this allows much more freedom of movement as well as enabling the

A simple adapter shoe can be fitted to a tripod head to enable the flash gun to be mounted on the tripod.

focus control to be adjusted quickly and simply. The most obvious and suitable stand for a flash unit used in this way is a tripod. Since flash is being used, the exposure time is short enough not to need a tripod for supporting the camera, so it might just as well be used to support the flash unit!

Most of the large and more powerful flash units are supplied with a bar, rather than a hot shoe or even a normal shoe, for attaching the unit to the camera. In this bar is usually a hole tapped with a thread to fit a standard tripod-mounting screw. The flash bar can therefore be screwed directly on to the top of the tripod, the flash unit attached, and the combination forms a stable and convenient lighting unit. For flash units which are not equipped with a flash bar and which are without a tripod socket in the base of the unit, it is possible to buy a flash bar as an accessory. An alternative to this is a small ball-and-socket unit with a shoe to take a flash unit on the top instead of the conventional screw thread to fit a camera. In this case the ball-and-socket unit

An example of a picture taken with hand-held computer electronic flash well to the left of the camera which was fitted to a tripod. This type of lighting gives much more shape to the subject.

is merely screwed to the top of the tripod instead of normal ball-and-socket head, and the flash unit is attached directly to it.

Another particularly useful accessory is a small clamp with a ball-and-socket head attached to it. This can be fixed to a shelf, chair back, the edge of a door, or any other convenient surface, and the flash unit is attached to it. This eliminates the need to carry a tripod and is equally effective. It is possible to make one of these clamp units quite easily from a small cabinet maker's clamp (the pressed-steel variety rather than the cast type). Drill a hole in the clamp arm opposite the clamping screw, size 6 mm and fix the ball-and-socket head to the clamp with a ¼ in (6 mm) Whitworth screw. To prevent the clamp from damaging any surface that it is attached to, it is best to use a flat-headed screw and to countersink the hole so that the screw-head is flush with the clamp arm; then glue a strip of rubber over the screw head and along the arm. This simple clamp, incidentally, is also extremely useful as a makeshift camera clamp. On location it can be used to fix the camera to a fence or gate to give the stability of a tripod without the inconvenience of having to carry a tripod around.

As a makeshift arrangement, the flash unit can always be taped to some convenient support and packed out with film cartons, pieces of foam and the like to adjust its position fairly accurately. For this reason, therefore, it is advisable always to carry a roll of masking tape in the bottom of the camera bag; it has all sorts of other uses such as holding the leaves of plants in the correct position, fitting a dress to a model properly and so on.

Quality of lighting
Even though the flash has been moved off the camera to a position slightly above and to one side of the lens, one of the major problems with a small flash unit still remains. The size of the light source (i.e. the flash tube in its reflector) remains fairly small, and for this reason any shadows cast on or

The flashgun was attached to the camera for this shot, which shows the typical hard black shadow behind the subject.

Holding the flash unit to the right of the camera gets rid of the hard shadow behind the face.

By using a card reflector and bouncing the light from it, the shadow behind the face is softened.

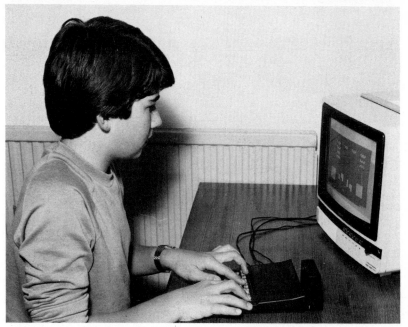

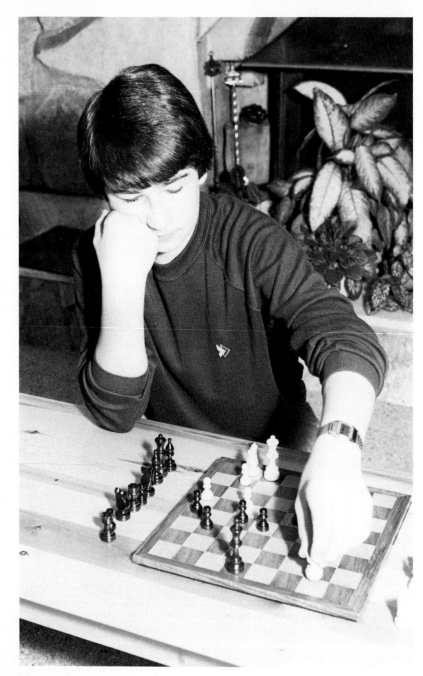

The flashgun, with card bounce reflector, was held to the right of the camera to soften the lighting for this picture.

44

by the subject tend to be hard, sharp and dense. In many cases this does not really matter but in others, such as portraits of attractive young ladies, the harsh nature of the shadows can be rather unflattering.

You can, however, soften the quality of the lighting considerably by using fairly simple techniques. What needs to be done, basically, is to increase the effective size of the light source so that the light, instead of having the sharp, brittle quality associated with a small source size, has a soft and all-enveloping quality which produces lighter and more luminous shadows with soft edges rather than sharp ones. This soft lighting quality can be produced either by bouncing the light from a large white reflector, or by placing a diffusing screen between the flash unit and the subject. Of the two methods, the diffuser is the more efficient because it does not increase the distance between the flash unit and the subject, and only cuts down the level of light by diffusing it over a larger area.

A useful size diffuser for small still-life set-ups and head-and-shoulders portraits is about 0.5×0.4 m, and for maximum efficiency the flash unit should be positioned about 0.3 m behind the diffusing screen at approximately the centre of the screen area. This will increase the effective size of the flash from a few square centimetres to some 0.2^2m. The exposure will, of course, have to be increased to allow for the amount of light absorbed by the diffusing material. A good starting point for tests is to give one stop more exposure; the increase in exposure is unlikely to be smaller than this although it may be half a stop or a whole stop more, depending on the particular diffusing material used.

Opal acrylic sheet makes a very good diffuser. It is about 3 mm thick and therefore does not need any sort of framework to keep it rigid. However, it is rather expensive, and a more economical solution is to use flexible diffusing material. A wide range of this type of diffusion material is available

world-wide under the brand name Rosco manufactured by an American company called Rosco Laboratories Inc. who specialise in the manufacture of light-control media for the movie industry. The diffusion materials available in the Rosco range include straightforward frosted sheets which give a very soft quality to the light, spun materials which give rather less diffusion, and silk materials which give less diffusion still.

The other way to provide softer lighting is to use a white reflector from which to bounce the flash. While a ceiling can be used, this tends to give lighting which is too much from the top, and any shadows that are formed will tend to be in the subject's eyes under the chin. This can give a rather heavy appearance. Much better is to have the reflector at about 45° to the side of the subject and 45° above the lens axis. A large sheet of white card can be used for a reflector, but an even better material is a sheet of white expanded polystyrene. This has the advantage of being rigid enough to stand up on its edge, yet light enough to be manouevred easily.

Place the flash unit about 0.3 m in front of the reflector and the light will be spread into a soft, diffused quality. A good alternative to the sheet of white card or polystyrene is one of the umbrella reflectors which are now freely available. These are often supplied with a special adaptor to enable them to be fixed to the top of tripod, and have a shoe which accepts the flash unit. The unit is then directed back into the umbrella and the combination forms an effective light source the same size as the diameter of the umbrella. Several different types of umbrella surface are available. The least expensive is a white silk-like material, but this not very efficient since it allows light to pass through as well as reflecting, so a large percentage of the light produced by the flash unit is wasted. It is, however, quite useful as a diffuser because the umbrella can be turned round to face the subject and the flash unit arranged so that the light passes through the umbrella.

A large brolly reflector gives soft shadows. Placed slightly to the left of the camera, as here, it gives delicate modelling. *Peter Smith.*

This photograph was taken with two brolly units, one either side of the camera. *Peter Smith*.

An increasingly popular method of using on-camera flash to attach a white card reflector above the flash unit to diffuse and soften the light. The flash unit is turned so that the light is bounced from the card to the subject.

A much more efficient umbrella is the type which is lined with reflective material. This is usually in the form of semi-matt foil which is backed by white cloth. The reflector can be used either way round so that a degree of control over the amount of diffusion is possible. When the umbrella is used with the foil inside, the lighting is rather more directional than if the umbrella is reversed and the white cloth side is inside. Another variation is an umbrella which has gold-coloured foil on one side rather than silver. This has the advantage of slightly warming the colour of the light so that the rather cold quality sometimes associated with electronic flash is lost. This type of reflector is particularly suitable for female portraits and for still-life pictures of such subjects as food.

Many of the more advanced portable electronic flash units now available, and usually designed primarily for professional use, have attachments that enable them to hold a card reflector at an angle of about 45° above the flash head. The flash head is then tilted upwards so that light is directed on to the white card which forms the reflector. This has the effect of increasing the size of the light source to that of the card, usually about 24 × 20 cm. A card reflector can be used with the flash unit mounted on the camera to give the advantages of a softer light source while still retaining the convenience of a camera-mounted flash unit. It can also be useful when shooting with extremely wide-angle lenses, as we shall see shortly.

Contrast control

When using a single flash unit to light a subject, the shadow areas tend to be rather dark, even when diffused or bounced flash is being used. This can cause the finished print or transparency to have a somewhat high contrast range, giving an overall hard appearance to the picture. In most cases, the result will be much better if the shadows can be lightened in some way. The great temptation is to add extension flash units in an attempt to put some light into the shadows. While it is possible to use multiple flash to build up the lighting in the picture,

as will be explained in the next chapter, it can often create more problems than it solves. A much more simple way to solve the problem is to use reflectors in the form of white card or polystyrene.

These reflectors pick up stray light from the flash unit and reflect it back into the shadows to lighten them. The big advantage here is that the lighting still retains its essential character and the lightening of the shadows remains completely natural. Unlike when using extra flash units to lighten the shadows, there is no possibility of causing double shadows, because the light reflected back into the shadows can never approach the same brightness as the unreflected light.

To begin with, the positioning of the reflectors will be a bit of a trial and error affair since their effects cannot really be seen until the film has been processed. But a good way to get an idea of the effects is to experiment with reflectors using a small floodlamp unit instead of a flash unit as the light source. By setting up the lamp and moving the reflectors around the subject it will be very easy to see the effects of the reflectors. As a general rule, try placing a reflector in a mirror position to that of the flash unit. In other words if, for example, the flash unit is positioned 45° to the left of the subject, position the reflector 45° to the right of the subject. This will then pick up the light spilled from the flash unit and reflect it back into the shadows quite efficiently.

Another useful arrangement which can produce very flattering results in female portraits is to place the flash unit behind and above the model and a reflector in front of her directing the light back into the face. This arrangement will produce beautifully backlit hair to give a halo effect while the light reflected back into the face will have a lovely soft diffuse qualty which will minimise any blemishes and produce a very attractive portrait.

It is possible to make use of the natural reflective properties of walls in rooms. For example, if a

Left: direct flash, mounted on the camera, is ideal for colourful subjects against a black background. *Brian Gibbs.*

Right: a powerful flash unit is necessary when photographing an active subject from a distance using a telephoto lens. *Chris Howes.*

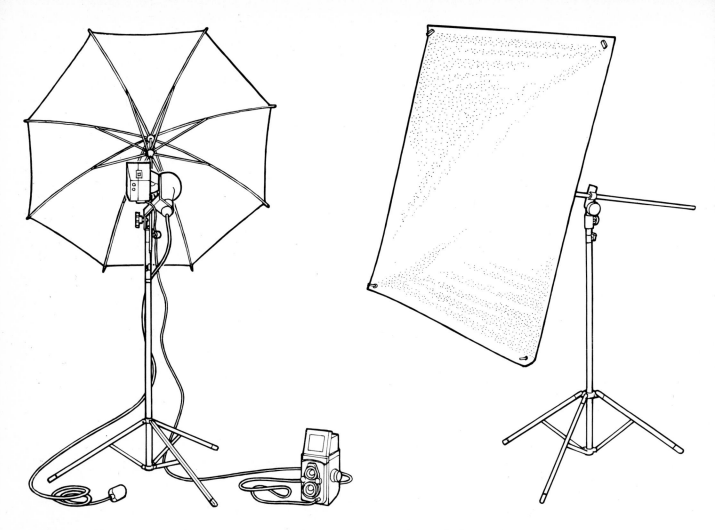

picture is being taken on location, it is a good idea to place the sitter in front of a wall near the corner of the room so that the wall at right angles to the background forms a reflector to lighten the shadows on that side of the face. But beware if colour film is being used, because the light reflected from the wall will pick up the colour of that wall and reflect it into the shadows. Everything should be all right if the walls are white or cream, but if they are, for instance, blue or green they can give

the picture a most unpleasant look.

While card or polystyrene reflectors are perfectly adequate for the vast majority of pictures, there are occasions when a brighter fill-in may be necessary. In this case a mirror can be quite useful and will almost totally reflect the light hitting it back into the shadows. Another good alternative is kitchen foil. This is usually available with one side shiny and the other side semi-matt, so there is a choice of

Far left: the Courtenay brolly flash, which can be used with any conventional flashgun. A reflector lamp can also be added to give a modelling light for setting up the lighting arrangement.

Left: reflectors help to control shadows simply and effectively. This Courtenay unit consists of a stand and fabric reflector which can be rolled up for easy storage.

This portrait was taken with a single flash unit positioned behind and slightly to one side of the model's head. A large mirror was placed in front of the model to reflect light back into the face.

light quality available. To soften the quality of the reflected light still further while retaining the intensity, try crumpling the foil and then flattening it out again.

There is nothing to prevent the use of more than one reflector to provide fill-in lighting. Two or three reflectors can be used all around the side of the subject opposite the flash unit to produce an all-round luminous effect. In fact this technique is widely used by food photographers. Food generally looks better if it is back-lit because this enriches the colours and produces an attractive sparkle on the moist surfaces of the various items in the shot. But the problem is that the front of the subject tends to fall into shadow so reflectors are used around the front of the subject to throw light back into these shadows. Some food photographers use a special screen reflector which extends right across the front of the set. This screen has a hole cut in it through which the camera lens is pointed to take the shot.

Using wide-angle lenses
Most small electronic flash units are designed with a lighting angle of around 75° across the diagonal of the reflector. This angle of illumination is intended for use with standard lenses and those with a longer than standard focal length. It is also suitable for slightly wide-angle lenses – 35 mm focal-length lenses on 35 mm cameras. However, if the flash unit is used with a lens of shorter focal length than this, say 28 mm focal length with a 35 mm camera, the illumination will fall-off towards the corners of the picture. This fall-off becomes more pronounced at still shorter focal lengths. To overcome this problem, many of the more advanced portable flash units have a prismatic attachment which can be fitted in front of the reflector to spread the light enough to cover the field of view of a wide-angle lens. Other units are fitted with a control lever which alters the position of the tube within the reflector, or alternatively changes the effective shape of the reflector. In each case, though, the angle of illumination is increased from its normal value to a much wider one to

enable the flash unit to be used efficiently with wide-angle lenses.

Yet another way of adapting the flash unit for use with wide-angle lenses is to use a diffusion screen in front of the reflector. This is particularly useful if the unit is being used with an auxiliary filter to change the colour of the light. In this case a filter holder is fitted to the front of the flash unit and the filter and diffusion screen are both inserted into it. Some units have more than one diffusion screen available which give varying degrees of diffusion according to the precise focal length of the lens being used. Typically there would be one for use with a 28 mm lens on a 35 mm camera and another for use with a 21 to 24 mm lens.

If any of the methods described earlier for softening the quality of the light from the flash unit are being used they will also, by virtue of the way they work, spread the light over a wider angle so that no other attachments are necessary when using a wide-angle lens. In all these instances, though, the exposure must be increased when using a wide-angle attachment. As a general guide, when using a prismatic screen adapter in front of the reflector, the exposure should be increased by one stop; when using a diffuser suitable for use with a 28 mm lens, an exposure increase of 1½ stops is necessary; and when using a diffuser suitable for a 21 to 14 mm lens, two stops is the normal increase in exposure which must be given. But, as with all exposure recommendations, these figures should be verified by individual tests. Naturally, if the wide-angle attachments are being used with a computer-controlled flash gun, the increase in exposure will be taken into account automatically by the computer-control circuitry.

Flash with long-focus lenses
The main problem that is likely to arise when using flash with a long focal-length lens is that, because the light intensity falls off according to the inverse square law, the intensity of the light reaching the subject when using a long-focus lens will be less

Page 54: for this product shot a large Hazylight flash head was positioned above and behind the bottle to give transparency to it, and reflectors were placed in front to lighten the label.

Page 55: for this shot, a large fish-fryer type light source was used above the product and several white reflectors placed around the front. *Mason and Riley Marketing Ltd.* Taken by Ian Wren, Leicester. Art direction by Alan Tyers, Three's Company Ltd, Birmingham.

than that reaching the subject when using a normal focal-length lens. (This is assuming that the flash unit is attached to the camera in each case.) With a powerful flash unit this merely means that the lens will have to be set at one or two stops wider aperture than it would with a standard lens. But with a less powerful flash unit it may mean that the lens has to be used at an aperture which is too wide for adequate depth of field. The simple way round this problem is to mount the flash unit on a tripod closer to the subject than the camera is, but outside the camera field of view. In this way the subject receives a higher intensity of light, yet the advantages of the long focal-length lens can still be retained.

Focal length and illumination

One point about using lenses of different focal lengths with flash attached to the camera is the effect they have on the level of illumination in different parts of the picture. Consider, for instance, a person sitting at a distance of one metre in front of a plain white background. This person is to be photographed to provide a head-and-shoulders portrait with a 35 mm lens, a 50 mm lens, a 100 mm lens, and 135 mm lens, each fitted to a 35 mm camera. In each case the flash unit is to be attached to the camera. Assuming that the correct aperture is calculated for the level of illumination at the subject in each case, the level of ilumination on the background will vary according to the focal length of the lens used.

If d_1 = distance from subject to background, d_2 = distance from camera to subject, and D = distance from camera to background $(d_1 + d_2)$, the level of illumination at the background will be:

$$\left(\frac{d_2}{D}\right)^2 \times \text{level of intensity at subject}$$

To produce a head-and-shoulders portrait using a 35 mm focal length lens, the distance between the camera and the subject would need to be about 0.6 m so the level of illumination at the background will be:

$$\left(\frac{0.6}{1.6}\right)^2 = 0.14 \times \text{intensity of light at subject}$$

In other words, the background will be underexposed by 2½ stops and will therefore appear as a tone 2½ stops darker than white.

Using the 50 mm lens, the camera-to-subject distance would be one metre, so in this case the level of illumination at the background will be:

$$\left(\frac{1}{2}\right)^2 = 0.25 \times \text{intensity of light at the subject}$$

So the background will be two stops darker than white. With the 100 mm and 135 mm lenses the intensity at the background will be 0.44 and 0.52 × intensity of light at the subject respectively. So the background will appear, respectively, 1½ and 1⅓ stops darker than white. From this it can be seen that as the focal length of the lens increases, the tone of the background becomes progressively lighter, simply because the distance between the subject and the background becomes a progressively smaller fraction of the total camera-to-background distance.

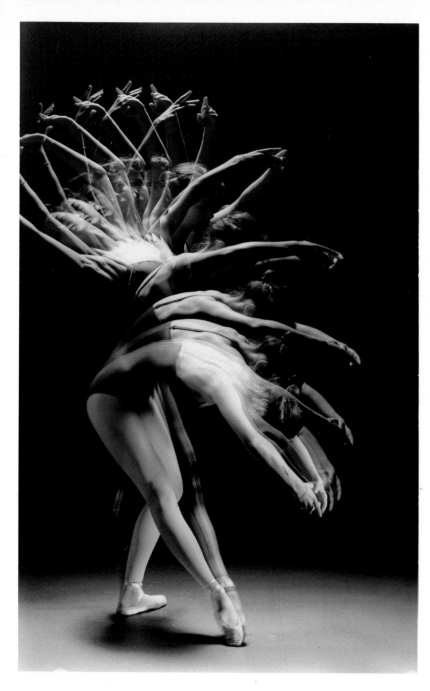

More advanced techniques

While, as we have seen in the last chapter, it is quite possible (and, in some cases, highly desirable) to build lighting arrangements from a single flash unit and one or more reflectors, there are many occasions when more than one flash unit can and should be used. The most basic requirement for using more than one flash unit is simply to increase the amount of light to enable a smaller lens aperture to be used, or to enable the subject to be photographed from a greater distance. Another reason is to create more ambitious lighting set-ups so that a model's face, for example, can be lit conventionally with one unit together with reflectors, while a second unit is used behind the model to give a halo effect to the hair. And perhaps even a third unit may be used to light the background.

Finally, multiple flash may need to be used when the subject is a large interior. With a single flash, whether placed on the camera or at any other point within the interior, the light would be neither powerful enough nor even enough to produce satisfactory results. However, before moving on to deal with techniques for using more than one flash, there are some technical problems which must be solved, most of which stem from the requirement to ensure that all the flash units fire simultaneously; unless this happens some of the flash units may fire after the camera-shutter contacts have closed and their light will be wasted.

Triggering multiple flash

There are three ways in which several flashguns can be simultaneously synchronised with the camera shutter. First, they can be connected to a multi-way adapter which in turn is connected to the camera synchronising socket. Secondly, some of the more advanced electronic flash units have extension units available which can be plugged into the main unit.

59

When the shutter is released to fire the main flash unit, the extension units also fire simultaneously. And thirdly, one of the flash units can be connected to the camera-synchronising socket and the others fired by light-operated slave units.

Multi-way adapters

The use of a multi-way adapter to fire several flash units simultaneously is certainly the simplest and least expensive method of all, but it can lead to problems, especially with electronic flash units. The method only works satisfactorily if all the individual flash units are of the same type. With expendable bulb-type flash units this means that they must have the same battery voltage, and the polarity of the batteries must also be the same. It is also a good idea to make sure that the batteries in each of the flash units are all at a similar point in their lives, otherwise when one of the flash units is charged another may not be. An important safety point when using more than one expendable bulb unit at a time is to insert the bulbs into the flash units before connecting the flash units together. Otherwise there is a very real danger of the bulbs firing as they are inserted into the flash units, which can easily result in badly burned fingers.

It is also important not to connect too many flash units, each with its own capacitor circuit, to a multi-way adapter. The reason is that the currents from the individual units are added together and can prove too much for the camera contacts, causing them to overload with the possibility of burning. Four is the absolute maximum number of individual flash units which should be fired through camera shutters, and for complete safety this should be reduced to only three, although this number is dependent to some extent on the size of the capacitors fitted to the flash units. Most flashguns these days use a 200 or 250 µF capacitor, and it is this value which limits the maximum number of guns to three or four. However, flash units with a smaller-value capacitor (say 100 µF) do not produce such a high firing current and so the number of units which can be used simultaneously can be increased to six or seven.

If multiple flash bulbs are to be used often, it is worth making up a special control box to enable three or four flash bulbs to be fired in safety. Such a unit consists simply of a 22.5 or 30 volt battery and a capacitor of about 500 µF value connected in the standard battery-capacitor circuit as shown in the first chapter in this book. But instead of a single flash-bulb holder, three or four jack-sockets are connected in series with the resistor and capacitor. Each of these jack sockets is of the type which short-circuits itself when the plug is removed.

Separate reflectors containing flash bulb holders are connected via leads to standard jack plugs which are then inserted into the jack sockets on the control box. If just a single flash bulb is being used, only one of these reflector units is plugged into the control box and the remaining sockets are therefore short-circuited. But when more than one reflector unit is used, the jack plugs are inserted into the sockets to connect the additonal reflector units in circuit. In this case, when the camera shutter is released, all the flash bulbs fire at the same time. It is possible to fire up to four flash bulbs using a simple circuit of this type, but it is not often that more than this number of bulbs need to be fired at any one time. By restricting the value of the capacitor to 500 µF and the voltage to 22.5 or 30 volts, the current flowing through the camera contacts is kept to a safe level.

Electronic flash and adapters

The use of electronic flash units with a multi-way adapter is potentially even more of a problem than it is with expendable bulb units. The cause of this problem is that different manufacturers use quite different triggering circuitry for their flash units. For example, the polarity of the triggering capacitor in some units is connected with its positive electrode to the common or earth side of the circuit, while in others the negative electrode is connected to earth. If units of these two different types were used together on a multi-way adapter,

Page 58: one of a series of colour transparencies on sheet film for a Mainline Railways catalogue. *Palitoy Ltd.* Art direction by Alan Tyers, Three's Company Ltd., Birmingham. Photograph by Derek Watkins. See page 75 for details of how the pictures were taken.

Page 59: a multiple flash technique was used for this stop-action shot of a ballerina. *Philips Ltd.*

the probability is that both units would fire as the second unit was plugged into the adapter. (Alternatively, both units may fail to operate at all.) The triggering voltage of different flashguns varies considerably, too, and for satisfactory operation it is essential that these triggering voltage should be the same for all units used with a multi-way adapter.

For these reasons, then, it is advisable only to use electronic flash units of the same make and type connected together through a multi-way adapter; units of the same make invariably have similar triggering circuits operating at the same voltage and can therefore be used comparatively safely. However, even with units of the same make and type, the current passing through the camera contacts increases in the same ratio as the number of flash units used, so if two units are connected to a multi-way adapter the triggering current through the camera contacts is doubled, if three units are used the current is trebled, and if four units are used the current is quadrupled. With some flash units the triggering current is fairly high even for a single unit, and if this is multiplied by two, three or four times it can be seen that the wear on the synchronising contacts in the camera will be rapidly increased. So it is best to treat the use of several electronic flash units connected together through a multi-way adapter as a makeshift arrangement for use only occasionally or for emergencies.

Extension flash heads

Many of the larger portable flash units are fitted with a socket into which can be plugged one or more extension flash heads. These units are similar in appearance to the master flash unit but the circuitry inside them is much simpler. In fact it consists of just a capacitor and flash tube with the usual triggering electrode. The unit is plugged into the main flashgun and the power supply in the main unit charges both the capacitor in the main unit and that in the extension unit. Then, when the shutter release is pressed, both flash units fire simultaneously. Some extension heads do not have

their own storage capacitor and instead share that of the main unit. With this type of unit the power is divided equally between the two flash heads, which means, of course, that the output from the main flash unit is halved. This type of extension is not as good as the type with its own capacitor but is, nevertheless, quite a useful alternative as well as being considerably less expensive.

The big advantage that extension flash heads have over using two or three separate complete flash units on a multi-way adapter is that, because the main flash unit is specifically designed to accept plug-in extension heads, there is no problem at all about compatibility and no danger that the units will fire prematurely or fail to fire at all. Moreover, because there is only a single triggering circuit handling all the flash heads, the current flowing through the camera shutter contacts remains the same irrespective of how many flash units are being used. Large studio electronic flash systems work in basically the same way as this. They generally consist of a central power and control console into which one or more flash heads are plugged. A single synchronising cable from the camera is then plugged into the console and controls all the heads simultaneously. Many of these large units are very flexible and sophisticated, having variable power control to each of the separate flash head outlets.

Slave units

Perhaps the most elegant answer of all to firing several flash units simultaneously is the use of electronic slave units. These are, in essence, small electronic switches which are sensitive to light. One of the flash units – the master – is connected to the camera-synchronising socket in the usual way while each of the other units is connected to a slave unit instead. When the shutter release is pressed, the master flash unit fires and the light from this unit is picked up by each of the slave units which switch electronically to fire the extra units. Since the operation of these slave units is virtually instantaneous there is no appreciable delay between the firing of the master flash unit and the firing of

the additional units. Early electronic slave units had fairly complex circuitry and required a battery to power them. Consequently, they were comparatively expensive. However, most of the modern slave units are very much simpler and are self-powered; that is to say they need no separate battery. They are quite inexpensive and are very small.

A development of the electronic slave system is used on many studio flash units for no other reason than to get rid of the long synchronising cable running between the camera and the flash control console. This can often be several metres in length and there is always the risk of someone tripping over it and either injuring themselves or damaging the camera by pulling the tripod over. So instead of a long, trailing synchronising cable, many systems now use a tiny infra-red flash unit attached to the camera and plugged into the synchronising socket, and a sensitive infra-red detecting slave unit wired into the control console.

The reason for using infra-red for this purpose is that it does not emit visible light and therefore has no effect on the lighting arrangement set up by the photographer. However, the infra-red receiver unit is also sensitive to visible light so, if necessary, a small conventional flash unit can be used instead. One of the problems with this type of triggering arrangement is that the slave unit is so sensitive that it can be triggered by someone turning on a fluorescent light some distance from the unit. As the starter causes the fluorescent tube to flash until it strikes, the slave treats this as a deliberate signal and triggers the flash set-up! But this is a small price to pay for the convenience that slave operation offers.

Where to place the flash units
Having settled on one or other of the means for triggering several flash units simultaneously, the question that now arises is that of where to place the flash heads to give the required lighting effect. The big danger here is simply to set up all the lights

where you think they should be and hope for the best. The results are invariably different from what was hoped for, and the main reason for this is that insufficient attention is paid to the distances between the subject and the various individual flash units.

If the flash units are of similar power and placed at similar distances from the subject, the lighting becomes too flat and there is the risk of multiple shadows which nearly always look unnatural.

When a lighting arrangement using more than one flash unit is set up, it is probably a person being photographed. When lighting a head-and-shoulders portrait, two flash units are generally needed: the main or key light and the fill-in. It is these two lights which control the character of the portrait,

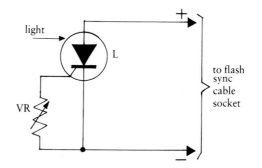

This simple slave circuit using a light-activated silicon-controlled rectifier (LASCR) fires the flash when a light is shone on the LASCR. $VR = 1\,M\Omega$. $L = 200\,P1V$ LASCR.

Sunpak slave unit plugs direct into the flash unit.

A main light to the right of the camera and a fill-in light to the left, almost as powerful, gives a lovely soft quality to this portrait.

and any others which may be added to the basic arrangement are simply to light the background (to produce accents on the hair, for instance).

The main light

The main light, or key light as it is sometimes called, sets the whole mood of the picture, and it is vitally important to get its position right before starting to add any further lamps. Generally the key light will be positioned to one side of and slightly above the subject so that it lights the subject from an angle of about 45° both to the horizontal and to the vertical. If the subject is a person, this will provide full lighting to one side of the face while throwing the other side largely into shadow. Alternatively, if the subject is looking away from the camera, the key light can be placed directly in front of the face and slightly above so that it casts a small shadow from the nose directly down towards the mouth. The trick here is not to place the lamp too high so that the nose shadow actually touches the lips. Used on its own, this particular lighting arrangement produces extremely dramatic results. The key light can also be placed directly above or beneath the subject's head, but these positions should be used with great restraint as they can tend to look rather gimicky. The other position for the key light is directly behind the subject so that the subject is outlined with a halo of light.

Fill-in light

Once the position of the main light has been fixed, the question of fill-in can be looked at, and this is where problems often start. The danger is to use a fill-in flash which is simply too powerful. Always remember that the purpose of a fill-in light is to do just that: to lighten the shadows cast by the main light, *not* to overpower the main light. If the fill-in light is too powerful, it will kill the shadows cast by the main light and destroy the character of the lighting arrangement. When placing the flash units in position and calculating the flash-to-subject distances, always remember that flash, like other forms of light, obeys the inverse square law. This means that if the flash-to-subject distance is

doubled, the amount of light reaching the subject is divided by four, not by two. So to compensate, the lens aperture must be opened by two stops.

The actual power ratio, and hence the brightness ratio, of the main and fill-in flash units will depend on the results required. For example, if a dramatic low-key picture is wanted, the ratio between the main light and the fill-in light will be bigger than if a light airy picture is required. For general purposes, a ratio of about 4 : 1 or 5 : 1 is suitable for black-and-white work. Also, it is difficult to place the flash units accurately for a higher ratio unless they are fitted with modelling lamps. For colour work the lighting ratio should be considerably less than this, and a ratio of 2 : 1 or 3 : 1 is advisable because the colour film cannot handle as great a brightness ratio as can a black-and-white film.

Let us look at an example. The main light is set up well to the side of the camera and slightly above the level of the model's head so that it provides a lighting direction of about 45° to the side and above the axis of the lens. The distance from the key flash to the subject's face is one metre. The fill-in lamp is to be placed as close to the lens axis as possible to give flat frontal fill-in lighting to the shadows. Assuming that a highlight-to-shadow ratio of 5 : 1 is required, how far away must this fill-in flash be placed? (For the sake of this example, assume that the main flash unit and the fill-in are identical units.) The formula for calculating the correct fill-in flash distance is, in fact, quite simple. To begin with, the brightness ratio required must be calculated. This is the brightness required in the highlights divided by that required in the shadows. So if the highlights are to be five times brighter than the shadows, the brightness ratio is 5 : 1.

Now, because of the application of the inverse square law, the distance of the fill-in flash should be equal to the distance of the main flash multiplied by the square root of the lighting ratio required. But there is a slight complication. Because the light from the fill-in flash falls on both the shadow side

of the face and the highlight side of the face, it not only lightens the shadows but also adds to the general lighting in the highlights. To compensate for this a factor of 1 must be subtracted from the required lighting ratio before the square root is taken. So the complete formula for calculating the fill-in flash distance is as follows:

$$D_f = D_m \sqrt{(R-1)}$$

where D_m = distance of main flash unit
D_f = distance of fill-in flash unit
R = required lighting ratio

Returning now to the example, if the main flash is at a distance of one metre from the subject and the required lighting ratio is 5 : 1, the distance of the fill-in flash will be:

$$D_f = 1\sqrt{(5-1)}$$
$$= 1\sqrt{4}$$
$$= 2 \text{ metres}$$

Here is another example. In this case the main flash unit is in the same position, but this time the lighting ratio required is only 2 : 1 since the shot is being taken on colour slide film.

$$D_f = 1\sqrt{(2-1)}$$
$$= 1\sqrt{1}$$
$$= 1 \text{ metre}$$

In other words, the distance of the main flash and the fill-in flash in this case are the same.

To eliminate the need for carrying out this calculation each time a shot is taken, the square root of the lighting ratio minus one can be calculated as a factor by which to multiply the main flash distance in order to find the fill-in flash distance. This has been done in the table above, right, which shows the distance ratio between main and fill-in flash units, assuming that both units are of equal power. To find the fill-in distance, multiply the main flash distance by the fill-in distance factor for the lighting ratio required. For example, if a lighting ratio of 4 : 1 is required and the main flash is one metre from the subject, the fill-in distance will be 1 × 1.7 = 1.7 m from the subject.

lighting ratio	fill-in distance factor
2 : 1	1
3 : 1	1.4
4 : 1	1.7
5 : 1	2
7 : 1	2.5
10 : 1	3

Exposure with fill-in flash

Once extra flash units are added to the basic lighting system, the problem of calculating the correct exposure becomes more complicated. It is fairly straightforward when two similar units are used at equal distances from the subject to give a lighting ratio of 2 : 1, but it becomes rather more difficult when setting up for other lighting ratios since the two flash units are placed at different distances from the subject. While it is possible to calculate the correct stop to use from the individual guide numbers and distances of the two flash units, a much simpler method is to use what is known as equivalent distance.

Equivalent distance

Equivalent distance is a method of averaging-out the brightnesses of the two flash units into the equivalent of a single unit at a closer distance than either of them. The formula for calculating this equivalent distance is fairly simple and is based upon the distance of the main flash from the subject and the ratio of highlight brightness to shadow brightness. The formula is as follows:

$$D_e = D_m \sqrt{\dfrac{1}{\left(1 + \dfrac{1}{(R-1)}\right)}}$$

where D_e = equivalent distance
D_m = main flash distance
R = lighting ratio

Here are a couple of examples. If the distance of the main flash from the subject is 1.7 m and the highlight-to-shadow brightness range is 4 : 1,

$$D_e = 1.7 \sqrt{\cfrac{1}{\left(1 + \cfrac{1}{(4-1)}\right)}}$$

$$= 1.7 \sqrt{\cfrac{1}{1.33}}$$

$$= 1.3 \, \text{m}$$

For the second example, the distance of the main flash from the subject is 2.1 m and the highlight-to-shadow ratio is 2 : 1.

$$D_e = 2.1 \sqrt{\cfrac{1}{\left(1 + \cfrac{1}{(2-1)}\right)}}$$

$$= 2.1 \sqrt{\cfrac{1}{2}}$$

$$= 1.5 \, \text{m}$$

Once the equivalent distance has been calculated in this way, the correct exposure can be calculated by using the guide number of the main flash. So in the first example, if the main flash unit has a guide number of 24 with the particular film being used, the correct aperture to use for the subject being lit by both the main the fill-in lamps will be 24 ÷ 1.3 = 18.5. So the aperture should be set at a point about a third of the way between f/16 and f/22. In the second example, if the main flash unit has a guide number of 16 with the film being used, the correct aperture will be 16 ÷ 1.5 = f/11.

Once more, to save a great deal of calculation, a table below gives factors by which the main flash can be multiplied to find the equivalent distance for a variety of highlight-to-shadow ratios.

lighting ratio	equivalent-distance factor
2 : 1	0.7
3 : 1	0.8
4 : 1	0.86
5 : 1	0.89
6 : 1	0.91
7 : 1	0.93
8 : 1	0.94
10 : 1	0.95

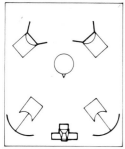

Four portraits which illustrate the use of multiple flash to give different effects. *Bowens Sales and Services Ltd.*

A standard portraiture arrangement using two brolly units, the left more powerful than the right, to light the model, and two direct units with barn doors for the background.

A similar set-up to the first, but in this case diffusers were used to give softer lighting to the background and to allow spillage on to the back of the model's head. The two brolly units used to light the face were of equal power to give a high-key effect.

To give a glamorous effect, a black honeycomb unit was fitted to one flash unit behind and above the model to give a bright halo at the top and side of her head. A silver honeycomb unit was used to the right of the model to highlight the other side of the hair. Finally, a diffuser was used in front of the third unit to give soft lighting to the face.

A silver honeycomb was used over the background unit to give a graduated tone on the background. The halo effect on the hair was given by a unit fitted with a black honeycomb above and to the right. Finally, a single brolly to the right of the camera produced the soft lighting on the face.

To use this table, simply multiply the distance of the main flash by the equivalent-distance factor to find the equivalent distance from which to calculate the correct exposure. For example, if the main flash distance is 3 m and the lighting ratio required is 4 : 1, the table indicates a factor of 0.86. So multiplying this by the main flash distance gives $0.86 \times 3 = 2.6$ m.

A rule of thumb

The equivalent-distance method is very suitable when highly accurate exposure calculations are necessary, but in many cases a rough and ready estimate of the reduction in exposure necessary to compensate for the fill-in flash is quite adequate. This again can be based largely on the highlight-to-shadow ratio. For ratios of 2 : 1 and 3 : 1, reduce the exposure by one stop from that calculated from the guide number and the main flash distance. For a ratio of 4 : 1 reduce the exposure by half a stop, for a ratio of 5 : 1 reduce the exposure by a quarter of a stop, and for any ratio greater than 5 : 1 leave the exposure unchanged. So if, for example, the lighting ratio required is 3 : 1 and the correct exposure calculated from the main flash distance and guide number is $f/16$, reduce this by stopping the lens down to $f/22$. Or when the required lighting ratio is 8 : 1 and the calculated correct exposure is $f/11$, then leave the camera set to $f/11$.

Another method

The alternative way to calculate the correct exposure when using two flash units is from the individual apertures required for each flash unit on its own. The formula is:

$$A_c = \sqrt{A_m^2 + A_f^2}$$

where A_c = aperture for combined units
$\quad A_m$ = aperture for main unit
$\quad\quad A_f$ = aperture for fill-in unit
So, for example, if both units are at three metres from the subject, giving a lighting ratio of 2 : 1, and have guide numbers of 24 with the film being used, both A_m and A_f will be $24 \div 3 = f/8$. The aperture

to use with both units together, then, will be:

$$\begin{aligned} A_c &= \sqrt{8^2 + 8^2} \\ &= \sqrt{128} \\ &= 11.3 \text{ or } f/11. \end{aligned}$$

Another example. If the main unit is 1.5 m from the subject and the fill-in is 2.6 m away, both with guide numbers of 16, giving a lighting ratio of 4 : 1, A_m will be $16 \div 1.5 = f/11$ and A_f will be $16 \div 2.6 = f/6.5$. So the correct aperture with both units will be:

$$\begin{aligned} A_c &= \sqrt{11^2 + 6.5^2} \\ &= \sqrt{163} \\ &= 12.76 \text{ or } f/13. \end{aligned}$$

The advantage of this method is that it is not necessary for both flash units to be the same type nor to have the same guide number.

Accent or kick light

A third flash unit can sometimes be added to provide an accent on part of the subject – often the model's hair. The purpose of this kick light is to give a small but relatively bright highlight without affecting the overall quality of the lighting arrangement. For this reason, the flash unit used as an accent light can be relatively low in power and is preferably shielded with a cylinder of black paper to prevent the light spilling outside the area where it is intended to fall.

One of the most suitable positions for this kick light is behind the subject's head facing at an angle slightly towards the camera. This gives that glamorous halo effect to the model's hair, making the subject stand out better from the background and therefore giving an impression of depth to the picture. It is most important to use a good lens hood when working with a kick light in this position because any stray light from the flash hitting the lens will cause flare which will lower the contrast of the picture, perhaps ruining it completely. But if the kick light is shielded as suggested above, this problem will largely be eliminated before it starts.

One very important point about accent lighting used in this way is that, in order to be effective, it must be considerably brighter than the light falling on the front of the model, otherwise the effect is almost completely lost. For this reason, the distance between the accent light and the subject should be between a half and three-quarters of the distance of the main flash-to-subject distance, assuming that both units are of similar power. Because accent lighting is intended simply to lift a small area relative to the rest of the subject, no allowance for it should be made in calculating the exposure. Base the exposure on the main and fill-in flashes as explained earlier and leave the accent light to pick out the area of the subject required. What it does in effect is overexpose this small area to give added sparkle and interest to the shot.

Background light

A separate flash unit is often desirable simply to light the background behind the subject. The basic concept is that if the background is of a similar tone to the subject the whole picture takes on a rather dull, flat appearance. So it is much better to have the background at a considerably lighter or darker tone than the subject. In effect this means that the distance between the flash unit and the background must be either considerably more or considerably less than the distance between the main flash and the subject, assuming that the two units are of similar power. To calculate the distance from the background to the background flash unit, refer again to the inverse square law. To make the background twice as bright in tone as the subject, the distance between the background and the flash unit needs to be roughly three-quarters of the distance between the main flash unit and the subject. If the background needs to be four times as bright as the subject, the distance needs to be half that of the main flash to subject. On the other hand, if the background needs to be darker than the subject, 1½ times the main flash distance will make the background half as bright as the subject, and twice the main flash distance will make it a quarter as bright.

If a fill-in flash is being used in addition to the main flash unit, the distance of the background flash must be calculated from the equivalent distance of the main plus fill-in units rather than the distance of the main flash unit alone. So if, for example, the subject is lit by a main unit and a fill-in unit giving a lighting ratio of 3 : 1 and the distance of the main flash is 1.5 m from the subject, the first thing to establish is the equivalent distance of the frontal lighting. This is done by referring to the table on page 66 which shows that the main flash distance must be multiplied by a factor of 0.8. In this example, then, the equivalent distance of the main and fill-in flash units is $0.8 \times 1.5 = 1.2$ m. Now if the background is required to be lit for a tone twice as bright as the subject, the distance between the background and the background flash unit must be three-quarters of 1.2 m which equals 0.9 m. One important point about backgrounds is to try to keep them as far behind the subject as possible. In this way, shadows of the subject cast by the main or fill-in light do not fall on the background to compete with the background lighting, which can give rise to confused and unpleasant shadow effects on the background.

Bare-bulb flash

One of the main problems associated with conventional flash units is that the light they produce is very directional because the flash bulb or tube is used within the reflector unit. If a perfectly natural lighting arrangement is required, this can lead to difficulties. For example, if a shot is being taken of a sitting room, the use of conventional units will produce a most artificial-looking picture. What is wanted is light similar to that which is normally used in the room. Fortunately, it is fairly easy to simulate natural room lighting by using bare-bulb flash units. These, as their name implies, are simply units without reflectors so that light from the tube or bulb travels in all directions to give a very soft, natural lighting effect.

The ideal position for these bare-bulb units is just below the ceiling of the room. The ceiling then acts

Left: this fire pump was photographed with the aid of three flash units. A large Hazylight unit was positioned above the pump to provide overall lighting and two more units fitted with diffusers were placed in line with the front and left-hand side of the pump to lighten shadows and produce highlights. The pump stood on a black-painted hardboard floor, and a roll of black background paper was used at a fairly large distance behind the pump to help make the colours stand out well.

To retain the effect given by the existing lighting in this bedroom shot, a single bare-bulb flash technique was used. The power of the flash was carefully chosen so that it did not overpower the warmer colour of the existing lighting.

as a large reflector to diffuse the light even further. Special electronic flash units without reflectors are available, but if a bulb unit is being used, the reflectors can often be removed from the unit by undoing a screw or two on the back of the flashgun. Alternatively, it is a simple matter to wire-up one or two screw-thread bulb holders and connect them to a battery or battery-capacitor unit to fire the bulbs. Since with an arrangement of this sort all the light comes from fairly high up in the room, it may be necessary to use one or more fill-in units to lighten any shadows being cast downwards by objects in the room, though large reflectors of expanded polystyrene can often be sufficient to act as fill-ins in this way.

Because the guide numbers given to flash bulbs and electronic units are calculated on the assumption that they will be used in an efficient reflector, these guide numbers no longer apply when working with bare-bulb flash. It is impossible to give hard-and-fast rules for the amount by which the exposure must be increased when a reflector is not used, but a good starting point is to calculate what the exposure would be with a reflector and then increase it by two stops. If the shot is being taken in a small room with very light walls and ceilings, one stop increase may be enough, but if the room is very large and dark three stops may be required.

Open flash technique

Most flash pictures taken these days are taken with the flash unit connected to the camera by a synchronising lead to ensure that the flash automatically fires at the moment when the shutter is fully open. However, there are times when this technique gives less than perfect results and an improvement can be gained by firing the flash manually. This non-synchronised system of firing the flash is known as open flash. The basic technique is to open the camera shutter on B (bulb) or T (time) setting, fire the unit manually, and then close the shutter again. This technique is particularly useful when photographing interiors during the hours of daylight when part of the room

A single brolly flash was used to light this small kitchen set. It was positioned to the left of the camera and slightly above it.

is lit by daylight coming through the windows, leaving other parts of the room as very dark corners which will be grossly underexposed if an exposure for the daylight only is given.

For a picture such as this, the camera aperture will often need to be stopped down to its smallest setting in order to produce sufficient depth of field in the picture to reproduce both near and far objects in the room equally sharp, and this will call for a fairly long exposure time, perhaps several seconds. So using the open flash technique, the

shutter is opened, and during the several-seconds exposure time the flash unit is fired to provide fill-in for the dark parts of the room. The shutter is then closed again at the end of the calculated exposure time.

This system works particularly well if the fill-in unit is arranged to put maximum light into the darkest areas of the room because the natural fall-off in intensity of the flash is automatically compensated for by the daylight entering at the windows. One very important point is to make the fill-in lighting

Left: a single diffused flash unit was used in this picture to lighten shadows given by daylight entering the window. It is important to prevent the fill-in flash overpowering the daylight or an artificial effect is produced.

One of a series of model railway photographs taken for a catalogue. *Mainline Railways division of Palitoy Ltd*. Art direction by Alan Tyers, Three's Company Ltd., Birmingham. Photograph by Derek Watkins.

The lighting set-up used for the model railway pictures on this page and on page 58. A large Hazylight unit was used as a background 'sky' and a long striplight along the front picked out the detail in the models. A sheet of white polystyrene reflected light on to the top of the models and another smaller sheet (not in position here) lightened the front of the model. The camera can be seen at the bottom right hand corner – it was a 5 × 4 in Sinar monorail fitted with a 210 mm lens.

as soft as possible. The simplest way to do this is to bounce the flash off a large sheet of white polystyrene, not forgetting to allow for the extra distance between the flash and the polystyrene when calculating the correct distance at which to place the flash so that the shadowed corners of the room are correctly exposed at the aperture determined by the long exposure for the daylight-lit parts of the room.

An extension of this basic system of interior fill-in lighting is the use of a long basic exposure combined with several individual flashes. This method is ideal for large dark interiors such as churches. A typical interior shot of a church would be looking down the nave towards the altar with a stained-glass window behind the altar. If the correct exposure to capture the detail of the stained-glass window is given, the rest of the interior of the church will be grossly underexposed and consequently lacking in detail in the print or transparency. Yet if a long exposure is given to capture the detail within the church interior, the stained-glass window will be grossly overexposed and will lose all detail.

Using the fill-in flash system, a very small stop on the camera is selected to enable an exposure time of several seconds to be given; the minimum exposure time is 30 seconds and the ideal is double this. During this exposure a number of individual flashes are fired from behind pillars, in doorways, behind pews and so on to put light into the darkened interior. Because churches are usually high vaulted buildings, several flashes from any one position may be necessary in order to build up sufficient exposure to register on the film. Because the basic exposure is several seconds in length, you can move about in the picture area quite freely without recording on the film as long as you keep moving. The reason is that you are never in any one position long enough to record an image on the film.

When using this technique it is best to work with an assistant who can remain by the camera holding a piece of black card. After each flash the assistant places the black card in front of the lens while the flash unit charges up ready for the next flash. The assistant counts off the seconds of the main exposure, interrupting it while the black card is in front of the lens. It is quite possible to shoot a picture using this technique without the help of an assistant, but the danger is that you may find yourself at the far end of the church at the end of the exposure time and by the time you get back to the camera the shot is overexposed.

A fairly powerful flash unit is required for this type of photography since the distance from the flash unit to the surface it is lighting tends to be rather large. It is virtually impossible to give any firm guidance on exposure because the individual surroundings in the building are so varied, as are the types and powers of flash units used. The only really satisfactory way to find out what exposure is needed is by carrying out tests. If a sheet film studio camera is being used for the shot, the ideal way to carry out the test is to use a Polaroid back to produce an instant print as a check on position and strength of the flash exposures.

The most important thing to remember when shooting interiors in this way is not to overdo the flash fill-in. The type of interior which will be shot with this technique tends to be rather dark (this is especially true of churches) and if too much fill-in illumination from the flashes is given the whole mood of the picture will be lost. For the basic exposure to capture detail in the stained-glass window, aim to overexpose by about one stop. In other words, if the correct calculated exposure, allowing for reciprocity failure, is 45 seconds at $f/32$, give 45 seconds at $f/22$. This will slightly overexpose the stained glass window to maintain the effect of the church being lit from the outside but not sufficiently to cause the detail to be burned-out and lost. If the exposure given is that calculated, the stained-glass window will tend to reproduce too dark and will give an unnatural effect to the picture.

The problem with this shot was one of balance. In order to retain detail in the stained-glass window, an exposure of 35 seconds at $f/32$ (allowing for reciprocity failure) was necessary. But this meant that the roof details and pews would be grossly underexposed. To increase the exposure enough to retain adequate detail in these areas would have burned out the detail in the window. The problem was solved by increasing the overall exposure to 35 seconds at $f/22$, causing the window to be slightly overexposed to retain realism, and by directing some twelve flashes of a large portable unit at the roof and pews from various positions within the church to give adequate exposure to these areas.

Synchro-sunlight

The idea of using flash out of doors on a bright, sunny day may at first seem rather pointless. After all, if there is plenty of natural sunlight illuminating the subject there would seem to be little point in supplementing it with flash. But flash, used as an auxiliary form of lighting, is extremely useful for softening hard shadows cast by a subject in bright, clear sunlight. The technique is called synchro-sunlight and is particularly useful when using colour reversal film because of the need to keep down the highlight-to-shadow ratio.

Generally speaking, this is one of the few instances where the flash gun is best used mounted on the camera to give flat frontal illumination. When the natural sunlight is from a position well to one side of the subject, large and very dark shadows are cast on one side of the subject's face. By using a small flashgun mounted on the camera, these shadows are lightened so that they retain detail without overexposing the sunlit side of the face. In this way the brightness range of the subject, and hence the contrast of the final picture, can be controlled within quite fine limits.

The major problem with synchro-sunlight techniques is getting the exposure right. When a single flash is used as the only light source, the exposure is relatively simple to calculate, as was explained in the chapter on flash and exposure; and the exposure need not be precisely right anyway because the latitude of the film will take care of a reasonable amount of over- or underexposure.

However, when flash is being used to control the contrast of a subject, the balance between the sunlight and the flash must be very accurately calculated or the resulting picture looks totally artificial.

79

Brightness range

The first job when using synchro-sunlight is to determine accurately the brightness range of the subject: the ratio of highlight-to-shadow readings. To do this, take exposure-meter readings of the brightest highlight and the deepest shadow in the subject; choose highlights and shadows in which detail is required, of course. Any type of exposure meter, whether built into the camera or a separate hand-held instrument, is suitable for this job. If the highlight and shadow areas to be measured are very small, it may be necessary to take the readings from a larger substitute area. For example, readings can be taken from the back of the hand held in a fully-lit position and then in a deep shadow position. The difference between the two indicated exposures gives the brightness ratio of the subject. For instance, if the shadow reading is 1/60 second at $f/5.6$ and the highlight reading is 1/500 second at $f/5.6$, the brightness range of the subject is roughly $8:1$ ($500:60$).

At this point a decision can be made as to whether fill-in flash is needed at all. If the subject-brightness range is less than $4:1$ for black-and-white work or $2:1$ for colour, there is no need to use fill-in flash to lighten the shadows. Indeed, if flash is used in these circumstances the resulting picture will tend to be weak and insipid. But if the brightness range is higher than these figures, fill-in flash may well improve the picture.

It is a good idea to try to group subjects under three headings to make it easier to decide whether fill-in flash is needed or not. The three headings are: shadow detail adequate; shadow detail too dark to record; and borderline cases.

Shadow detail adequate

This is likely to be the case when the picture is being taken on the beach or with snow on the ground, or if the subject is holding a book of newspaper. The sand, snow or paper will almost certainly reflect enough light into the shadows for them to record adequately. So in these cases flash is not needed.

Shadow detail too dark

If the model is posing framed in a doorway and the picture is being taken from the inside of the building looking out, and detail is required in the background outside as well as in the model's face, the film will not cope with the brightness range, especially if reversal colour film is being used. The subject-brightness range in this case will be far too high to allow adequate shadow detail if the exposure is based on the background, or adequate highlight detail if the correct exposure is given for the model. Here, fill-in flash improves the picture enormously. Other cases could be pictures taken in woods or high-walled gardens, or in bright outdoor conditions where there are no natural reflectors.

Borderline cases

This is the most difficult class to define properly. In fact it is usually far easier to define suitable subjects after the negatives have been processed! It is difficult to make prints from these negatives which will retain detail in both the highlights and the shadows. Models photographed in town streets and squares often fall into this class, and the results can be improved by using flash as long as great care is taken not to overdo it. Otherwise the resulting picture will look dull and flat, and the whole character of the natural lighting will be lost.

Balancing the lighting

The balance of illumination when using synchro-sunlight depends on the actual subject-brightness range required. With a simple flash unit this is controlled by moving the flash unit nearer to or further away from the subject. The procedure is quite straightforward. First, take an exposure meter reading to determine the correct exposure needed with sunlight only. Set the camera controls to the indicated values, using the combination of shutter speed and aperture to produce sufficient depth of field and to halt any movement in the subject. If the camera has a focal plane shutter, a shutter speed at the slower end of the scale will have to be used, and if the flash unit is electronic the shutter speed will have to be slower

Page 78: a flash unit was used to lighten the beams in this old market building and avoid a heavy black area without detail.

Page 79: sunlight streaming through the window behind the model is filled in with a small camera-mounted flashgun diffused with a handkerchief.

than about 1/60 second, depending on the particular camera concerned. So in the latter case the aperture will be largely governed by the restriction on shutter speed which can be used.

Next, divide the guide number for the flash unit by the aperture selected for the daylight-only exposure. The result of this calculation will indicate the distance at which the flash must be placed for the daylight and the flash to light the subject equally. This will provide a subject-brightness range of 2 : 1 which, generally speaking, will be too flat except for colour reversal film, although even then 3 : 1 would look more natural.

The next step, then, is to modify the distance calculated to give a subject contrast that is required. For instance, if a subject contrast of 5 : 1 is required, the flash-to-subject distance must be double the distance calculated in the previous step. It may seem slightly puzzling that, with both the daylight and the flash illuminating the subject equally, the subject-brightness range is 2 : 1. But the explanation is quite simple. The highlights are lit by both the daylight and the flash while the shadows are lit by the flash only, so the highlights receive twice as much light as the shadows. The same applies when doubling the flash-to-subject distance; instead of the subject-brightness range of 4 : 1 it is actually 5 : 1. A full range of subject-brightness ranges and flash-to-subject distances is given in the table on the right, together with exposure adjustments.

Here is an example. The subject is a girl being photographed in a garden and the exposure meter readings indicate that the highlight-to-shadow ratio is four stops or 16 : 1. This is too high to be aesthetically pleasing so it is decided to use flash to reduce the subject-brightness range down to 4 : 1 which is ideal for the slow-speed black-and-white film being used. The meter indicates an exposure to daylight of 1/60 second at f/11, and the electronic flash unit to be used has a guide number of 33. This guide number is divided by the aperture to arrive at

Flash distances for synchro-sunlight

D = guide number ÷ camera aperture

required subject brightness range	flash distance	exposure adjustment
clear bright sun		
2 : 1	D	−1 stop
3 : 1	1.5D	−½ stop
4 : 1	1.75D	−½ stop
5 : 1	2D	0
hazy sun		
2 : 1	1.25D	−1 stop
3 : 1	1.75D	−½ stop
4 : 1	2D	0
5 : 1	3D	0

a flash-to-subject distance of 3 m which will give a subject-brightness range of 2 : 1. The table above indicates that to produce a subject-brightness range of 4 : 1 the distance calculated must be multiplied by 1.75, so in this case the flash-to-subject distance is $3 \times 1.75 = 5.3$ m.

Obviously, because the amount of light on the subject has been increased by using fill-in flash, the exposure given will have to be modified. At a subject-brightness range of 2 : 1, twice the light is falling on the subject so the lens must be closed down by one stop. At larger subject-brightness ranges less adjustment is necessary. The table indicates that a half-stop reduction in exposure is necessary at a subject-brightness range of 4 : 1. So the final exposure will be 1/60 second at f/14 with the fill-in flash positioned 5.3 m, from the subject. This means that the shot must be taken from a distance of 5.3 m, possibly using a long focus lens in order to produce a sufficiently large image of the subject on the negative; or the flash unit must be positioned some feet behind the camera. For this purpose a fairly long extension lead for the flashgun is a good investment.

Variable power units

Several modern electronic flash units have a variable power control built into them which enables the user to select, in addition to full power, a fraction of the maximum power of the unit. The Braun 370BVC, for example, enables the light output of the unit to be reduced in steps from $\frac{1}{2}$ to $\frac{1}{64}$ of full power, each step being half of the preceding step. This type of unit is ideally suited for synchro-sunlight work because it can be used attached to the camera at a suitable fraction of maximum power rather than having to be placed on a tripod or other support at a greater distance from the subject than the camera.

Once the required subject-brightness range is known, the selection of a suitable fraction of the maximum output of the flash unit is extremely simple. It is one divided by the subject-brightness range minus one. So for a subject-brightness range of $5:1$ the correct fraction of the flash unit's power is $1 \div (5-1) = \frac{1}{4}$. For a subject-brightness range of $5:1$, then, the flash unit would be used attached to the camera but set to a power output of $\frac{1}{4}$ instead of full power. This is obviously much more convenient than having to set up the flash unit at a different distance from the subject than the camera.

If a variable-output flash unit is not available, it is possible to reduce the effective power of the unit by using a diffuser over the bulb or tube. For example, tissue paper reduces the amount of light reaching the subject by about half and a handkerchief reduces the light to roughly a quarter of its normal brightness. Obviously, the exact amount by which the amount of light is reduced depends on the materials themselves, so if accurate information is required tests should be carried out with the aid of a Photoflood bulb and an exposure meter. Point the Photoflood bulb, in a reflector, towards a white or light-coloured wall and take a reflected-light exposure meter reading from the wall. Place the tissue paper or handkerchief in front of the lamp and take another reading. The difference between the two readings indicates by how much the light has been cut. One stop difference indicates that the light has been halved; two stops shows that it has been quartered, and so on.

Using computer flash

Modern computer flash units are also ideally suited for synchro-sunlight work and can be used attached

Power setting on variable flash units for synchro-sunlight

required subject brightness range	power setting	exposure adjustment
clear bright sun		
2 : 1	1 (full power)	−1 stop
3 : 1	$\frac{1}{2}$	−$\frac{1}{2}$ stop
4 : 1	$\frac{1}{3}$	−$\frac{1}{2}$ stop
5 : 1	$\frac{1}{4}$	0
hazy sun		
2 : 1	$\frac{3}{4}$	−1 stop
3 : 1	$\frac{1}{3}$	−$\frac{1}{2}$ stop
4 : 1	$\frac{1}{4}$	0
5 : 1	$\frac{3}{16}$	0

Computer flash setting for synchro-sunlight

Camera set to $f/11$

Note. If adjustments are possible in whole-stop increments only, choose the higher or lower subject brightness range, whichever is the more suitable.

required subject brightness range	flash aperture setting	exposure adjustment
clear bright sun		
2 : 1	$f/11$	−1 stop
3 : 1	$f/8$	−$\frac{1}{2}$ stop
4 : 1	$f/5.6$–$f/8$	−$\frac{1}{2}$ stop
5 : 1	$f/5.6$	0
hazy sun		
2 : 1	$f/8$–$f/11$	−1 stop
3 : 1	$f/5.6$–$f/8$	−$\frac{1}{2}$ stop
4 : 1	$f/5.6$	0
5 : 1	$f/4.5$–$f/5.6$	0

to the camera. But instead of setting the aperture control on the flash unit to the same value as that on the camera, it must be set at a smaller value if a subject-brightness range of greater than 2 : 1 is required. For example, if a subject-brightness range of 3 : 1 is required, the aperture setting on the flash unit is set to one stop larger than that on the camera; in other words, if the camera aperture setting is f/11 the setting on the flash unit must be f/8. This automatically halves the light output from the flash unit to give the correct subject-brightness range. Likewise, if a subject-brightness range of 4 : 1 is required, the aperture setting on the flash unit must be 1½ stops larger than that on the camea; and if a subject-brightness range of 5 : 1 is required, the aperture setting on the flash unit must two stops larger than that on the camera.

Balancing backlighting

So far, synchro-sunlight has only been dealt with as a means of using flash to lighten shadows as a result of using the sun as the main source of illumination. But there is another form of synchro-sunlight which gives quite different results. This involves using the flash as the sole source of illumination for the model's face and shooting into the sun to give back-lighting to the hair. This method gives the well-known and very attractive halo effect on the hair, but two things must be borne in mind for really satisfactory results which look completely natural.

First, the back-lighting given by the sun must be the brightest part of the picture. If it is not, the picture will merely look rather flat and uninteresting as well as giving a totally unnatural appearance. To produce this bright effect the areas of the subject highlit from behind must be overexposed to some degree. Secondly, the flash must not be so powerful that it overpowers the back-lighting, yet it must be bright enough to give necessary detail in the model's face.

It is not possible to take an accurate direct reflected-light reading to determine the exposure

for the back-lighting; reflected-light readings are not really accurate enough in these circumstances. So either use a meter with an incident-light attachment, or take a reflected-light reading with the sun behind you. Set the camera lens to either one or two stops larger than the meter indicates, according to the degree of halo effect required. One stop is sufficient in most cases, especially with colour reversal film, but two stops can give that extra sparkle to the picture by producing slight halation.

The next step is to calculate the flash-to-subject distance by dividing the guide number of the flash unit by the aperture set on the camera and then increasing this distance by half as much again. So, for example, if the exposure-meter reading indicates an exposure of 1/60 second at f/22 and the camera is set at 1/60 second at f/16 to give an average degree of halo effect, the calculated flash distance with a guide number of 33 will be 2 m. This should then be multiplied by 1.5 to given an actual flash distance of 3 m. Alternatively, if a variable-output flash unit is being used, the power can be set to ½ to give the same effect. And if a computer flash unit is being used, the aperture setting on the flash unit should be set to f/11.

When using flash for this form of synchro-sunlight it is often better to bounce the light from a reflector rather than pointing the flash unit straight at the model. Bounced flash produces softer shadows and looks far more natural than the rather harsh results which can be produced by using direct flash. One of the modern system flash units used in conjunction with its clip-on bounced flash unit is ideal for these applications.

Relieving deep shadows

The techniques of synchro-sunlight can be used for subjects other than portraits, too. Consider, for example, a brightly lit, very light-coloured building with an open doorway leading into a very dark interior. By giving the normal exposure as indicated by the exposure meter to retain detail in the

The stained glass window was the main subject here, but a small amount of fill-in flash was used to lighten the altar and the walls.

light-coloured walls of the building, little or no detail will be recorded inside the doorway. Instead, the doorway will appear in the picture as a featureless black hole. However, by using the synchro-sunlight technique, a flash unit can be used to put enough light into the interior to ensure that detail is recorded on the film. The method is exactly the same as for relieving shadows in a portrait.

Take an exposure-meter reading to establish the exposure necessary for the building using shutter speed of 1/60 second or slower if the camera has a focal plane shutter and an electronic flash unit is being used. Then decide on the ratio required between the sunlit outside of the building and the shadowy interior. A ratio of at least 4 : 1 should be used or the results will look very artificial indeed. Calculate the necessary flash distance or power from the tables and take the shot.

Flash in dull weather

On dull days, flash can be used outdoors as the main source of illumination for a picture and can be arranged to produce a quite passable simulation of natural sunlight. In this case the flash unit should not be used on the camera but should be positioned considerably higher so that it points down towards the subject at an angle of at least 60°. A tall tripod or camera clamp attached to the branch of a tree or some similar support will be necessary to position the flash unit at this angle. As with other synchro-sunlight techniques, calculate the correct distance for the flash unit from the exposure necessary for the natural lighting. But in this case place the flash unit rather closer to the subject than the calculated distance, say about three-quarters of the calculated distance. This will then produce a subject brightness range of about 3 : 1 with the flash providing the main lighting and the natural light the fill-in.

Naturally, care has to be taken in choosing a suitable subject when shooting with this technque. Because the brightness of the flash falls off very quickly due to the inverse square law, the technique is not suitable for subjects with a great depth. It is best kept for use with small, well-confined subjects such as close-ups of flowers and the like. Synchro-sunlight is one of the most interesting and useful of all flash techniques. In many ways it is not as simple and straightforward as using flash as the sole source of lighting, but it is capable of solving a great many problems associated with very contrasty subjects. For this reason, it is well worth spending some time experimenting and testing the various synchro-sunlight techniques in order to establish exactly what effects are possible. This information will then form a sound basis for future synchro-sunlight work.

Flash in the studio

For many years there was a general aversion among both amateur photographers and professionals to the use of flash in the studio for portraits and still-life photography. The main reason seemed to be that it was thought that flash gave very flat, almost shadowless lighting or the very opposite: harsh lighting with deep black shadows. The critics of flash in the studio, though, would happily use tungsten lighting which, if treated in the same way as flash, gives exactly the same results. So, looking from the other side of the fence, if tungsten lighting produces results which you are happy with, you can use flash in the same way to produce equally acceptable shots.

With the increasing exposure of the public at large to superbly-lit colour photographs in advertisements and women's magazines, many more photographers have begun to realise just what good results can be achieved with the careful use of flash. The majority of these advertising pictures, especially those of carefully composed still-life subjects such as food and jewellery, are taken in the studio with flash lighting. True, the flash equipment is a far cry from the little flashgun that clips into the hot shoe on a camera, but nevertheless it is still flash. So there must be certain advantages in using flash in the studio rather than using tungsten lighting, otherwise many top professionals would not use it.

Advantages of flash
The light produced by an even quite modest flash unit is far brighter than that produced by an average tungsten lighting unit. A comparison of the exposures needed with flash and tungsten lighting for subjects in similar conditions will confirm this. The duration of the flash itself is only around 1/1000 second so a hand-held camera produces sharp results. With tungsten lighting the exposure may well be several seconds at a similar stop so the

camera must be fitted to a tripod. The advantage of the very short exposure time, of course, is that it enables the photographer to remain totally mobile and able to move around the model, constantly changing viewpoint and angle to produce the best results. Also, since the model can move freely or even jump around, action shots can be taken in the studio.

Another major advantage is that the flash unit, even one with a built-in modelling lamp, produces little or no heat. This means that the sitter does not fry and become red-faced while sitting under the lights; and food or flowers stay fresh-looking for longer. This, of course, allows the photographer to take more time and trouble in setting up the subject and composing the picture. Finally, flash provides a very consistent output with a colour temperature around the same as that of average daylight.

Tungsten lighting, on the other hand, gives light that is much redder than daylight and the colour tends to change as the lamps age. The advantage of consistent output and colour temperature is that once a particular batch of colour film has been tested, the results should always remain the same. A colour temperature the same as that of daylight means that the same film type can be used both outside and in the studio, and this naturally makes for greater economy.

Studio flash units
For all of the reasons just given, electronic flash is the most versatile of artificial light sources for shooting all types of subject in the studio. Unfortunately, though, it does have the disadvantage of being rather expensive; and because of the rather complicated electronic circuitry involved there is, of course, more to go wrong. Studio flash can be broken down into three different categories of ascending complexity, power and cost. These three types of unit are portable hand units with extension units connected to them, self-contained floor-standing units, and high-power consoles feeding one or more separate flash heads.

Portable hand units
These are the type of units that were dealt with earlier in the book. Basically, they are the normal electronic flash unit which is designed to attach to the camera – albeit a rather high-power portable unit – and with the facility to enable one or more extension heads to be plugged into the main unit so that fill-in flash, accent lighting or background lighting can be provided. Although this sort of arrangement is perfectly adequate for an amateur's studio, it is not really suitable for professional work because the power output from the units is simply too small. It can, though, be quite useful as a portable stand-by system which can be taken out for possible use on location; but even there it would probably be of limited use.

Self-contained studio units
With the increasing interest in electronic flash as a studio lighting system came the requirement for powerful yet relatively inexpensive studio units. This demand has been met by several

Page 86: a well-equipped studio for advertising photography, with a sheet-film camera on a mobile stand rather than a tripod, and a large Hazylight flash unit powered by a separate power unit on the left.

Page 87: a fashion shot taken with a soft Hazylight unit to avoid harsh shadows. *Michael Barrington-Martin.*

A self-contained studio flash unit: the Courtenay Colorflash 4.

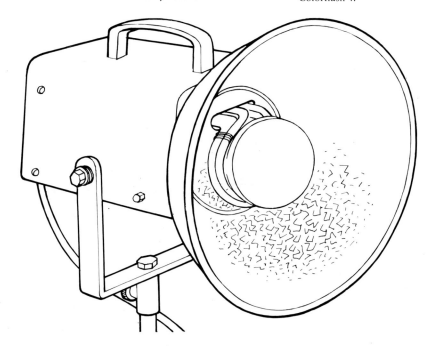

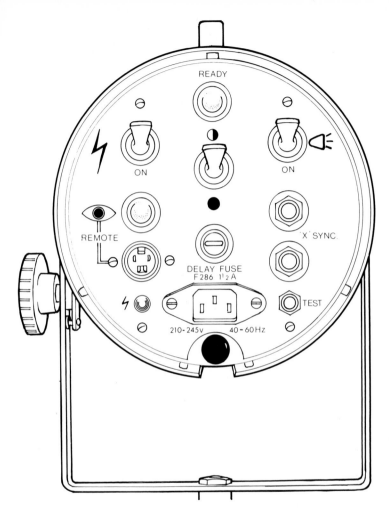

The control panel of the Courtenay Sola studio flash unit. The switches are (left to right) flash on, power – up for half, down for full – and modelling lamp on. Above the centre switch is the charge indicator. On the left-hand side is a slave sensor and below it a socket to take a remote slave.

Opposite these are two sync sockets and below these a test button.

manufacturers in the form of powerful yet compact self-contained units. Each unit consists of a power pack, flash tube, modelling lamp, reflector, and often a built-in photo cell in a single compact unit. The power output of these units is considerably higher than that of the portable hand-type units and this gives two major advantages. First, the brightness of the flash is considerably higher and, secondly, the recycling or recharging time is very much less than with a hand-type unit – often as short as two seconds.

Small studio units of this type can be fitted to portable telescopic stands and positioned anywhere in the studio just like tungsten lighting systems. They only need to be connected to the electrical mains and to the camera through a synchronising lead. In many cases, several of these units are used together in a multiple flash arrangement, and to eliminate the need for a separate synchronising lead from each unit to the camera (or to a multi-way adapter connected to the camera) a special socket is usually built into each unit to enable them to be linked together with linking leads. Then a synchronising lead is connected from the camera to one of the units and when the shutter is released all the units fire simultaneously. Some systems have a development of this arrangement which uses a photo-electric slave unit. This is either built permanently into the unit and can be switched in or out of circuit, or it may be a separate unit which can be plugged into the synchronising socket of the unit. Again, one of the units is connected to the camera by means of a synchronising lead and when this unit fires as a result of pressing the camera shutter-release, the light from it triggers all the other units.

The light output of these self-contained studio flash units is nearly always variable. Some units have a simple two-position switch which enables the unit to be set for half or full power, but others have a rotary switch which enables the power to be set at $\frac{1}{8}$, $\frac{1}{4}$, $\frac{1}{2}$, or full power. One of the major advantages of these units is that they have

89

The Bowens Bo-Lite studio
flash system includes
stands, barn doors,
diffusers, honeycombs,
slave units, leads, and a
large suitcase-type
container to transport it all.

modelling lamps built in. This means, of course, that the units can be accurately positioned to give exactly the lighting required visually instead of having to wait until the pictures are processed before seeing exactly what the lighting looked like. Most units use a domestic 150 watt bulb as a modelling lamp; these are both economical and easy to obtain anywhere. With virtually all units the modelling lamp can be switched off independently of the flash circuit, and in some the brightness of the modelling lamp is variable in proportion to the power setting of the flash unit. This is a major advantage as it enables the lighting to be set up accurately from the points of view of both power and position with the final effect shown visually.

The self-contained studio flash unit forms the centre point of a whole lighting system. Typically, the system includes reflectors of various shapes and sizes from narrow highly directional ones to large soft flood types, a range of umbrellas, both translucent and reflective, barn doors for masking the light from certain parts of the subject, snoots for concentrating the light in a small area, filters and filter holders, honeycomb attachments to direct the angle of light spread, and so on. But perhaps even more important, the units, being self-contained and compact, can easily be carried about in the boot of a car to be used on location. In fact some recently-introduced systems are available fitted into a suitcase-like container which holds the complete system ready to be picked up and taken on location. With a light output of up to 1000 joules each, these self-contained units are powerful enough for quite large studio set-ups, and because they can be inter-connected, two or more can be positioned behind a large translucent diffuser to provide a higher level of light.

Large studio units
At the top end of the electronic flash lighting scale are large, free-standing power console units to which are connected one or more separate flash heads. They are intended solely for use in the studio, being too large and heavy to be easily

transported for location work. This type of unit is characterised by an extremely high power output (typically 1000 to 20 000 joules) and extreme flexibility and versatility. The main drawback of this equipment, other than its size and weight, is the cost; you could buy three or four Hasselblads for the same price as a typical studio flash outfit. However, on the plus side, these large and powerful studio units enable virtually any type of work to be carried out. The output from just a single flash head is sufficient to light a whole room set of reasonable size on its own or supplemented by one or more small fill-in heads.

As mentioned above, the console unit contains all the power circuitry, and the separate heads are plugged into this console. Two or more consoles can also be connected together to increase the power available for the flash heads. The power consoles are usually mounted on castors and can be positioned close to the camera, enabling the photographer to adjust the power without having to clamber all over the set. A synchronising lead connects the camera to the power console to fire the flash units in the usual way.

The enormous power produced by these large studio units is of great use, both when lighting a fairly large area such as a room set and when shooting a still-life set-up such as food. In the first instance the large amount of light is needed to illuminate the whole of a fairly large area, and in the second case it is needed to enable a small aperture to be used. The type of camera normally used for shooting food illustrations is a $12 \times 10\,\mathrm{cm}$ or – becoming increasingly popular – $24 \times 20\,\mathrm{cm}$ sheet film camera. Even when using a small aperture such as $f/22$ or $f/32$, the depth of field on these cameras is very small indeed when shooting at fairly close range, and for a food shot, for example, where the depth of the subject from front to back can easily be as much as half the distance from the subject to the camera, a really tiny aperture around $f/90$ is often needed in order to produce sufficient depth of field.

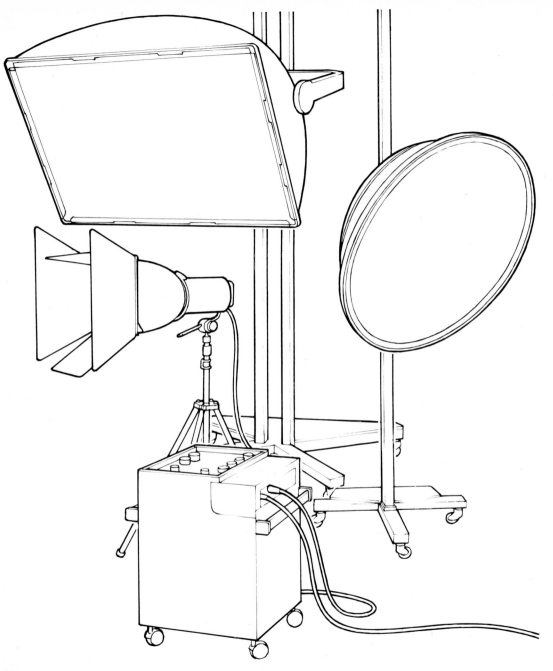

An advanced studio flash system from the Swiss company Bron Elektronik AG. In the front is the Broncolor 606 control console with an output of 6000 joules which can be used to power up to four flash heads. Immediately behind it is the Broncolor Standard head fitted with barn doors and a tripod stand. Beside it is the Broncolor Rondo head on a castor stand, and at the back the big Broncolor Hazylight head on its mobile floor stand.

Broncolor 303 and 404 power units with a standard head. These units have four outlets to enable several flash heads to be used simultaneously.

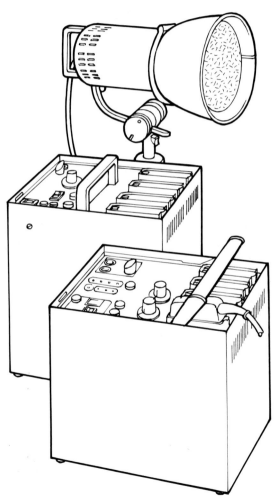

Large studio flash units enable these very small apertures to be used. For example, a typical 6000 joule unit has a guide number of about 210 with 64 ASA film. This means that, with the camera set to give an image on the film half the size of the subject (not at all uncommon when using a 24 × 20 cm camera) and the flash head around 1.7 m from the subject, there will be sufficient light falling on the subject to enable the camera to be set to an aperture of *f*/90, even allowing for the one stop increase in exposure made necessary by the long extension of the camera bellows.

All large studio flash systems have variable power output, some on a straightforward ⅛, ¼, ½, full power scale, but there are others which take this variable power output to its logical conclusion. These have the power control calibrated in steps which correspond to half a stop on the camera aperture scale. So if, for example, a shot is being taken at *f*/64 and tests show that the picture is slightly underexposed, instead of opening the lens aperture by half a stop which may throw parts of the subject out of focus, the power control on the flash unit console can be turned up one step to increase the power of the flash by the equivalent of that half stop.

These large studio flash units are available with a variety of different lighting heads with reflectors similar to those used for tungsten lighting. There are fairly deep, narrow reflectors to give directional lighting, wider but shallower reflectors to give a softer result, and many others in between. A wide range of attachments is available, too: snoots to concentrate the light into a confined circle, spot-light lenses to give a highly directional light producing strong, hard shadows, and so on.

Perhaps the most significant development in studio flash lighting during recent years, though, has been the soft-light source which is to be found nowadays in the studios of just about any advertising or fashion photographer worth his salt. Soft-light sources consist of very large flash heads, commonly

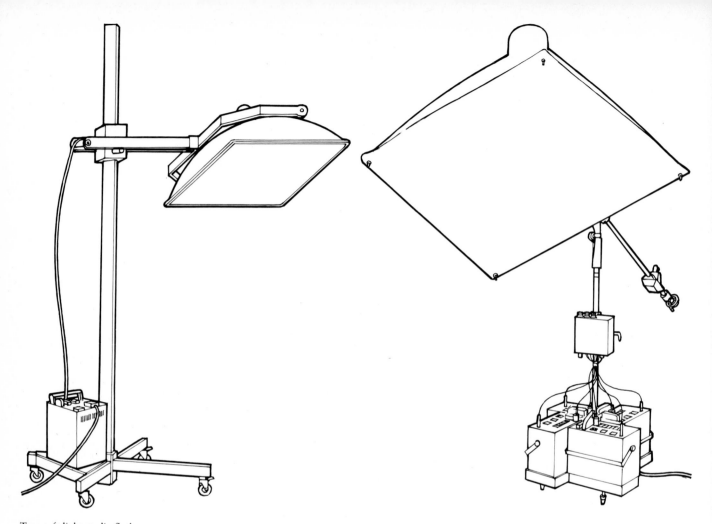

Two soft-light studio flash heads. On the left is the Broncolor Hazylight and on the right the Bowens Quad Windowlight.

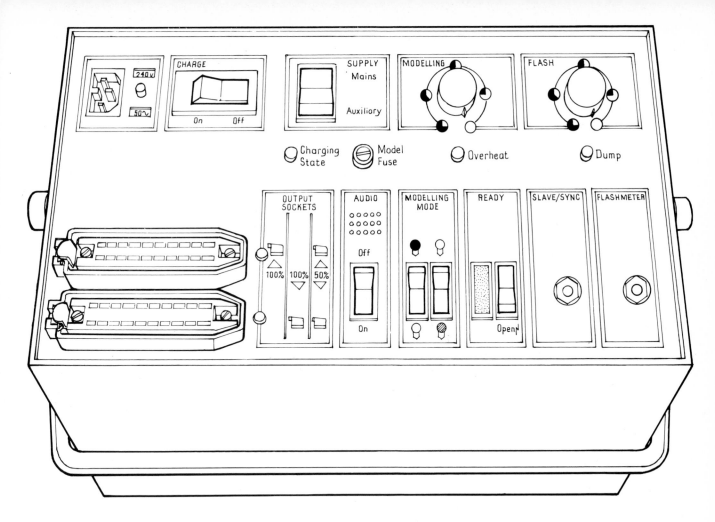

Control panel of typical power console.

called 'fish-fryers', 'swimming pools' or 'hazylights' which produce lighting very close to soft hazy sunlight out of doors. Common examples have a source size of 1 metre square, and some units can be at least twice this size. For colour work, this large, soft-light source is ideal. The light seems to get all round the subject, producing beautifully soft, luminous shadows that are full of detail rather than the hard, black shadows that are so commonly associated with flash.

As with the self-contained units, large studio flash systems have modelling lamps built into the flash heads, although the power of these modelling lamps is usually considerably higher than those used in the self-contained units. Many use 500 or 1000 watt tungsten-halogen lamps, which makes them ideal for use as a tungsten lighting source as well as flash if necessary, but some have fluorescent tubes as modelling lamps. With both types the brightness of the modelling lamp is nearly always variable in proportion to the power output setting on the console unit. On the larger and more advanced studio units the output to each flash head socket is adjustable independently so that, if necessary, one flash head can be used at full power while others are used at half or quarter power.

When equipping a studio with a large electronic flash system such as this, the type of flash heads chosen will obviously depend to a large extent on the type of photographs to be taken; but a good general-purpose outfit which will cover most needs consists of a 5000 to 6000 joule power console with a soft source hazylight and two general-purpose flash heads with two or three different reflectors each. This will provide sufficient variety of lighting to cope with straightforward product shots, still-life set-ups of food, flowers, jewellery and the like, portraits, full-length fashion shots and small- to medium-size room sets.

Triggering is usually by means of a synchronising lead which is connected from the camera to the console unit, although more and more manufacturers are changing over to infra-red triggering. With this system a tiny flash unit fitted with an infra-red filter is mounted on the camera and connected to the flash synchronising socket.

Built into the console is an infra-red sensitive slave unit so that, when the camera shutter is released, the tiny infra-red flash unit triggers the console and so fires the main studio lighting. This again is an advantage if more than one console is being used as it enables them to be sited in different parts of the studio without the inconvenience of having trailing leads connecting them together. In this way, each console can be located close to the flash heads it is powering.

Reflectors

One of the most useful accessories in any professional's or serious amateur's studio is several large sheets of white expanded polystyrene. These can be bought from builders' merchants in sheets up to 2.4 × 1.2 m and in various thicknesses. The best thickness to choose is 50 or 75 mm because the sheets can then stand up on their own without elaborate supports. These reflectors are used in conjunction with either the soft-light source or the more direct units and provide beautiful soft fill-in illumination to the subject without any danger of producing ugly crossed shadows. A great many studio photographers in fact never use more than one light source for their pictures, preferring the more natural fill-in produced by these large white reflectors.

Bounced flash in the studio

For those who cannot justify the very high cost of a large studio flash system, the results produced by the large soft hazy light or fish-fryer type of light source can be obtained to some degree by using bounced flash with a relatively small flash unit used in conjunction with a large white reflector. The technique involves pointing the flash unit, not at the model or still-life set-up, but at a sheet of white expanded polystyrene or card suspended above. The purpose of this is to increase the apparent size

of the light source and give a soft result. This technique was dealt with in some detail in the chapter on 'Simple lighting techniques', but a few extra points are relevant here.

The important thing to remember when using bounced flash is not to get too close to the subject. With the flash unit mounted on the camera, the nearer you get to the subject the shallower becomes the angle between the flash, the reflector and the model. The shallower this angle becomes, the longer the facial shadows will be, so stay at about 3 m from the model and use a long-focus lens. This longer distance will also help with perspective and give much more natural results. Shadows cast on the face will be lightened slightly by light reflected back from the walls of the room, and this is all to the good. Be careful, though, when shooting colour, because if the walls of the room are coloured this colour can be reflected back into the model's face.

Direct the flash gun so that the light hits the reflector or the ceiling about 0.6 m in front of the model. Mask off the bottom of the flash unit with card to prevent any direct light reaching the model, as this can completely spoil the effect. One small problem with bounced flash is the possibility of shadows under the chin. However, these are easily overcome by getting the model to hold a sheet of white card horizontally at about waist level. The light will then be reflected back under the chin, just to relieve the shadows slightly.

Flash meters

These were dealt with briefly in the chapter on 'Flash and exposure', but the studio is where the flash meter really comes into its own, so more detail is necessary at this point. The fundamental purpose of a flash meter is to simplify the accurate determination of exposure when using flash to save the photographer the time, trouble and cost of making extensive tests, leaving a set-up standing in the studio, and the possibility of having to carry out an expensive re-shoot.

Flash-exposure determination is comparatively simple and straightforward when using a single flash unit, because all that is necessary is to divide the guide number by the flash-to-subject distance to calculate the aperture at which the camera should be set. (Although even this needs to be modified according to the type of surroundings in which the shot is being taken.) But accurate electronic flash-exposure determination becomes progressively more difficult with the increasing complexity of the lighting set-up. When using fill-in, bounced flash, multiple flash, synchro-sunlight and close-up techniques it is often necessary to carry out extensive tests and calculations to arrive at the theoretically correct exposure. Even then, it is difficult to be really sure that the exposure is correct until the results are seen, and so the prudent photographer will bracket the exposure at plus and minus half a stop and probably plus and minus one stop as well. All this, of course, adds considerably to the cost of shooting the picture. So it can be seen that the price of a flash meter can quickly be saved in material and time costs. The meter also enables other vital tasks to be carried out such as establishing the subject-brightness range by taking highlight and shadow readings.

In the same way that modern microelectronics has revolutionised in-camera exposure metering systems, it has also enabled more advanced and versatile flash meters to be produced; in fact the modern flash meter tends to look more like a programmable pocket calculator than anything else! Many of the modern innovations are most definitely to the advantage of both the meter and the user. For example, instead of the once inevitable moving-coil meter as a readout system, the trend now is more and more towards the use of light-emitting diodes (LEDs) and liquid crystal displays (LCDs). These have several advantages. In the first place, they are much more robust than the old-fashioned moving-coil meter which could easily jam up if the meter was accidentally dropped. Secondly, because the readout is digital, the degree

of accuracy is much higher than with a needle – for instance, if the meter reading should be 15.4, the digital readout actually indicates a reading of 15.4 rather than leaving the user to interpolate a needle position somewhere between 15 and 16. Thirdly, these modern flash meters are considerably lighter and more compact than earlier types with moving-coil meters because they do not have the bulky and heavy magnet necessary to make a moving-coil meter work.

Many of the modern flash meters now also take into consideration the ambient-light conditions as well as the flash itself. This enables the photographer to choose the most suitable shutter speed to avoid the problem of ghosting or secondary blurred images when using flash in high ambient light. When used in this way the flash meter works on a similar principle to a shutter-priority automatic camera.

All flash meters take incident-light readings, although an increasing number are designed for reflective use as well. Like all exposure meters, flash meters are calibrated to a mid-grey tone – actually 18 per cent reflectance. When a flash meter is being used in its incident-light mode, this mid-grey calibration point has little bearing on the reading given and the exposure indicated because it measures light falling on the subject rather than light reflected from it, and the individual tones and colours in the subject do not affect the reading at all. However, when used as a reflected-light meter, these latter factors do affect the meter reading and hence the exposure indicated.

While a surprisingly high percentage of subjects integrate to 18 per cent grey (which is why this particular tone is chosen as a calibration point), many do not. There may be small but important areas of the subject which are very light or very dark in tone, and if a straightforward reflected-light reading is taken from the whole of the subject these areas would be over- or underexposed respectively. For example, in a still-life set-up on a white

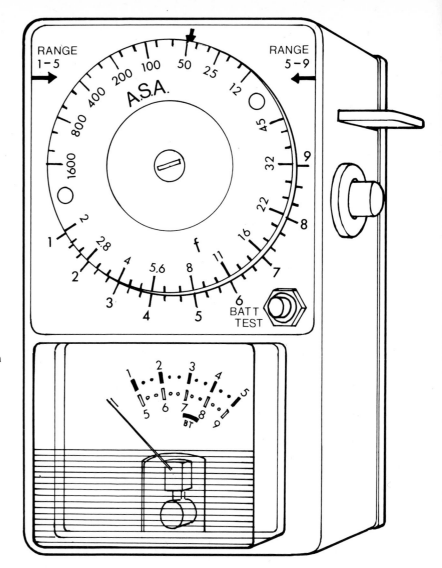

Courtenay 303 flash meter has two ranges covering nine stops; e.g. from f/2.8 to f/45 with 100 ASA film. The meter is connected to the flash unit by a synchronising cable to enable the flash to be fired from the subject position for an incident-light reading.

Circuit diagram of a simple flash meter for the home constructor.

background, the background would have an over-proportionate effect on the reading indicated by an averaging reflected-light flash meter, and small shadow areas of the subject would become very dark or totally black; whereas if the same still-life was composed on a black background, highlight areas of the subject would tend to be overexposed because of the lack of light reflected from the black background. In cases like this it pays to take two readings from the subject, one in an important shadow area and one in an important highlight area, and give an exposure midway between the two. This ensures that the shadows and highlights are sufficiently exposed to record detail.

This problem is almost totally overcome, especially in the case of colour transparency work, if the meter is used in its incident-light mode. Because the meter reads the light falling on the subject, the subject itself has no bearing on the reading and so, once tests have been carried out to establish the

film-speed setting on the meter which produces the most consistent results, a single incident-light reading will almost always produce the best results. An exception to this rule is when the shot is lit predominantly from behind. In this case two incident-light readings should be taken, one with the meter pointing at the flash head and the other pointing at the camera; then an exposure midway between the two indications is given.

What this in fact is doing is measuring the lighting ratio of the set-up. It is possible to use this method to determine the exact position and distance of fill-in flash when using a multiple-flash lighting arrangement. When the main flash has been positioned correctly, take an incident-light reading from it and then use the flash meter in its incident light mode to test the fill-in flash at various distances from the subject or various settings of the power control on the console. If the flash meter has a domed light receptor rather than a flat one, it may be necessary to construct a small tube of black

Many attachments are available for self-contained studio flash units. This series of pictures illustrates the effects given by three of them. Near right: no attachment fitted. Below near right: silver honeycomb attachment. Far right: black honeycomb attachment. Below far right: translucent honeycomb attachment. In each case a single Bowens Bo-Lite flash unit was used. *Bowens Sales and Service Ltd.*

paper to slip over the receptor so that it receives light from only one direction. Normally, of course, the domed receptor receives light from anywhere within a 180° radius.

So, to establish the lighting ratio, first of all point the meter at the main flash and make a note of the reading. Then point it at the fill-in flash and again note the reading. Dividing the main light reading by the fill-in reading gives the lighting ratio. If the meter has a reflected-light mode, it is perhaps better to measure the subject-brightness range rather than the lighting ratio. In this case take a close-up reflected light reading from an important highlight and another from an important shadow, divide the highlight reading by the shadow reading and the result is the subject-brightness range. From these figures it is possible to see whether any adjustment to the position of the main or fill-in flashes is necessary.

System meters

As flash meters become more sophisticated there is a growing trend towards treating the basic meter as the centre of a complete exposure-metering system. This means that, as with system cameras, the meter will accept a wide range of attachments which enable it to do specialised jobs more efficiently. The standard meter is fitted with a small diffusion dome for incident-flash readings and this is often on a slide which enables it to move to one side to convert the meter into a reflected-light instrument. However, the feeling in some areas is that a large diffusion dome gives better accuracy than a small one, so some meters now have this large dome available as an accessory and others are supplied with a large dome as standard. Some meters have the photo-electric cell under its dome, whether large or small, on a rotating head. This enables the light receptor to be pointed in any direction while the indicating part of the meter remains stationary for easy reading.

Another accessory often available is a flat incident-light receptor which again is sometimes supplied with the meter and sometimes available as an accessory. The most important use for this diffuser is for measuring lighting ratios as explained above. A few dual incident- and reflected-light flash meters now have available for them a spot attachment which enables them to be used for taking reflected-light readings from very small areas of the subject without the need for bringing the meter itself close to the subject. Typically, these spot attachments have an acceptance angle of about 10° rather than the normal 40° or so of the standard reflected-light meter. Actually, 10° is really too wide to qualify as a true spot meter, but it is a considerable improvement on the normal acceptance angle when it is necessary to measure a small area.

Other accessories available for system flash meters include tiny light-receptor domes on the end of a fibre optic which enables incident-light readings to be taken from positions which are inaccessible to the complete flash meter, microscope adapters which enable readings to be taken through the microscope eyepiece, and neutral-density diffusers which extend the range of the meter by two or three stops at the high-intensity end of the scale.

As was mentioned earlier, many of the new generation of flash meters are also capable of measuring ambient or continuous light. This means that a single meter will do the job of both a flash meter and a conventional exposure meter, thus saving on the amount of equipment which has to be carried for use both in the studio and on location.

These multi-purpose meters also simplify such tasks as calculating synchro-sunlight exposures. With the aid of one of these meters all that is necessary is to take a reading of the ambient light (daylight or artificial) and then adjust the power of the flash unit, or move its position, until the combination of shutter speed and aperture for the flash is equal to or less than that for the ambient light on its own, depending on the particular subject-brightness range that is required for the situation.

Conventional meters and studio flash

When using studio flash equipment with built-in modelling lights, it is possible to devise a method for using a conventional exposure meter to establish the correct exposure for flash. All that is necessary is to establish the correct flash exposure for a sample subject and then use a conventional exposure meter to take a reading using the modelling lamps to light the subject, making sure that the meter is set to the speed of the film being used. When the meter calculator dials have been set according to the reading obtained on the meter, simply check which shutter speed is positioned against the aperture used for the correctly-exposed flash shot. This shutter speed then becomes the reference point when using the meter to determine a flash exposure.

Here is an example. Suppose that it were established by tests that an aperture of $f/22$ was necessary to give a correctly-exposed colour transparency of a typical still-life subject in the studio. With the modelling lamps switched on in the flash head or heads, take a meter reading using a conventional exposure meter and set the calculator dials accordingly. Now look to see which shutter speed is indicated alongside the $f/22$ mark — 1 second, perhaps. This becomes the reference point for future readings. So when a new subject is set up to be photographed by flash in the studio, take a meter reading with the modelling lamps switched on, read off the aperture alongside 1 second and this is the correct aperture to use when shooting the subject by flash. This method of metering is quite accurate, and if the brightness of the modelling lamps is variable in proportion to the flash output, a conventional meter used in this way can do almost everything a special flash meter can do. It is certainly a good deal better than guesswork and can be used until the cost of a special flash meter can be justified, or as a back-up system if the flash meter is out of commission.

Working with studio flash

The basic principles of using self-contained studio flash units and several conventional heads on a large console-type studio flash unit are exactly the same as when using two or more portable flash units in a multi-flash set-up, as explained in the chapter 'More advanced techniques'. The advantage of studio flash units, though, is that, because the power of each unit can be varied and modelling lamps are built into the units, it is much easier to set up a lighting arrangement than when using several portable units. In fact the lighting can be built up in exactly the same way as when using tungsten lighting.

The first step is to place the main light source so that it gives the kind of modelling required for the subject. Once this has been set, the modelling lamp in the fill-in flash unit can be switched on and the power and position of this unit adjusted until the shadows in the subject are at the right density. Next, any accent or kick light can be switched on to lift the model's hair, and finally the background light can be added and adjusted until the background is exactly the right tone. Then, once the correct exposure has been established, either by using a flash meter or by making calculations, a synchronising cable is plugged into the camera and the shot taken. All this is very straightforward and exactly the same in principle as when using other forms of lighting. However, studio flash (especially the large, soft fish-fryer or hazylight type of unit) really comes into its own when used for product photography and room sets. So the rest of this chapter is devoted to some of the effects possible when using these large units.

Limbo backgrounds
One of the most popular methods of shooting product photographs is to have the product on a completely white background and foreground. This

Page 104: a simple but effective photograph of a commemorative medallion collection taken with a single overhead light source and a reflector in front of the camera.

Page 105: the clean white background is given by using the Hazylight as a background and lighting the front of the subject by reflected light only. *Massey-Ferguson (UK) Ltd.* Art direction by John Harlow, Three's Company Ltd., Birmingham. Photograph by Derek Watkins.

In this studio set-up the Hazylight is being used as a background to back-light the bottle of sherry, which is standing on a sheet of black acrylic.

is known in the trade as a 'limbo' shot because the product appears to be suspended in limbo. With a fish-fryer, this arrangement is very easy to create. The background, which is usually a wide sheet of strong white paper or, preferably, matt white laminate, is fixed to the front of a table positioned against a wall and the free end of the paper or laminate is curved up the wall to form a continuous sweep coming down the wall and on to the table. The product is positioned towards the front of the sweep, and the whole lot is lit by a fish-fryer positioned above and slightly in front of the subject.

This lighting arrangement is ideal when shooting in colour because it enables the true colours of the subject to be reproduced without being modified by heavy shadows. It is also very often used when the photograph is to form part of an advertisement. By positioning the product accurately when the photograph is taken, the headline and copy (the wording of the advertisement) can be laid over the plain white background to form the complete advertisement. This gives a much more acceptable result than cutting around the product and printing the headline and copy on tone-free white paper. It looks much more professional, too. However, when using black-and-white, this type of lighting and background set-up tends to produce rather flat, insipid results because of the lack of shadows and contrast, so other more dramatic lighting arrangements are often used for black-and-white work.

Graduated background

To provide some contrast in the background when shooting in black-and-white, and to enrich the colours in the subject when using colour film, a graduated background is often created. This is where the background starts off at the top of the picture as a total black and becomes gradually lighter until, at the bottom of the picture, it is completely white. The transition in tone from black to white is usually arranged to be partway up the height of the subject, and this can inject an awful lot of life into an otherwise fairly dull shot. Again, using a large source fish-fryer or hazylight, this type of background is very easy to achieve. The basic background set-up is exactly as for the limbo shot with the white paper or laminate attached to the front of the table and sweeping up the wall behind it. But this time the fish-fryer is positioned above and slightly behind the subject to give a slight degree of back-lighting. A barn door is then fixed to the back of the fish-fryer so that no light falls on the part of the background sweeping up the wall. This barn door can be a specially-made attachment for the fish-fryer; it clips into position on a pair of hinges and can be adjusted backwards and forwards so that the shadow it casts can be positioned accurately on the background.

Alternatively, it can be simply a piece of black paper attached to the back of the unit with masking tape. (A roll of masking tape is one of the most valuable items in any photographic studio!) A more gradual change from black to white on the background is achieved by making scissor cuts in the edge of the black paper barn door and bending the strips so formed to different angles. This enables the edge of the shadow to be adjusted from fairly sharp to very soft and gives a little more control over the finished result.

Because the subject in a graduated background shot is back-lit, the front of the subject tends to be rather dark and, if it is a product shot, this tends not to please the client. So in order to get some light into the front of the subject, an expanded polystyrene reflector is placed each side of the camera to reflect light back into the front of the subject. Using the reflectors in this way puts just enough light into the front of the subject to relieve the excessive darkness without overpowering the basic quality of the back-lighting. Also, because the subject is back-lit, it is essential to use a good lens hood when shooting subjects on a graduated background. The best type is the bellows lens hood which can be adjusted to the maximum length possible without causing vignetting of the corners of the picture.

This delightful collection of Palitoy dolls was photographed on 20 × 24 cm colour film using a Hazylight flash head above and white reflectors either side of the camera.

A graduated background for this pack shot was chosen to make the colourful boxes stand out better. It was achieved by taping a piece of black paper to the back edge of a Hazylight to cast a graduated shadow on the white background. *Photo Technology Ltd.*

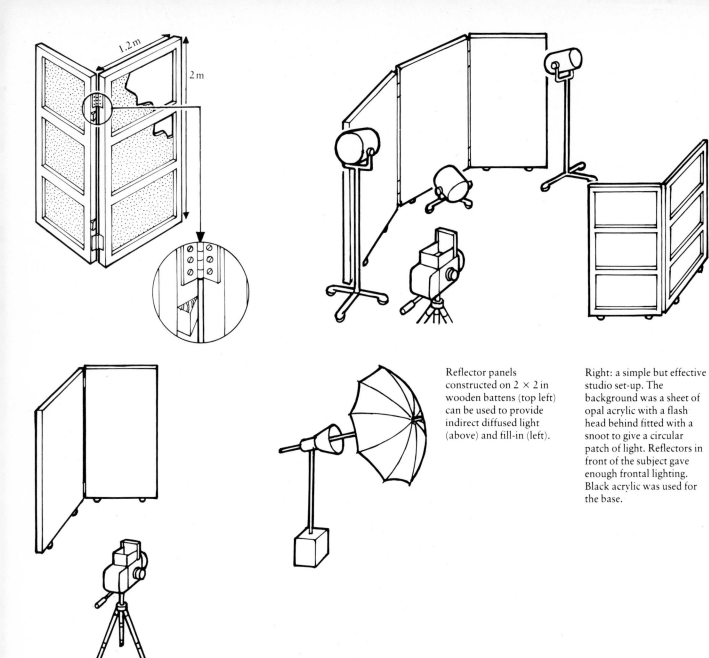

Reflector panels
constructed on 2 × 2 in
wooden battens (top left)
can be used to provide
indirect diffused light
(above) and fill-in (left).

Right: a simple but effective
studio set-up. The
background was a sheet of
opal acrylic with a flash
head behind fitted with a
snoot to give a circular
patch of light. Reflectors in
front of the subject gave
enough frontal lighting.
Black acrylic was used for
the base.

Reflective backgrounds

A system of background and lighting which is highly suitable for subjects such as jewellery, electronic components and other technological pieces of equipment (even cameras) is obtained by placing the objects on a polished surface and lighting them so that they are reflected in this polished surface. One of the most suitable materials for the reflective background is black acrylic sheet. This is highly glossy and reflects any objects placed on it very well indeed.

The idea is to place the sheet of black acrylic flat on a table and suspend a sheet of black background paper or black curtaining material at the back of the set so that nothing from behind is reflected in the sheet of acrylic. Arrange the objects to be photographed on the acrylic sheet and light them from directly above or from slightly behind with a fish-fryer or any other fairly large light source. This will pick out the top surfaces of the subject, giving tremendous sparkle to the shot and producing beautiful reflections in the acrylic sheet. As with the graduated background, reflectors may be necessary either side of the camera to reflect a little light back into the front of the subject. An alternative way of using a reflective background is to position the light source – in this case it must be a fish-fryer – so that it is itself reflected in the acrylic sheet. Objects placed in the pool of light formed by the light source have really deep, dark reflections rather like trees reflected in a sunlit pond.

An interesting effect is created by positioning the fish-fryer above the acrylic sheet and angling it so that the edge of the fish-fryer is reflected partway across the acrylic sheet. In this way the front or lower part of the picture has a clear, bright background which cuts off sharply to total inky blackness. The objects to be photographed are placed on the acrylic sheet so that they fall within the brightly-lit area and so have these deep, rich reflections. Once again it may be necessary to use reflectors in front of the subject to relieve the shadowed portions a little. But it is important not

The Olympus camera was placed on a sheet of shiny black acylic and black background paper hung behind for this shot. A Hazylight provided light from above and two reflectors were used to lighten the shadows and give sparkle to the chromium parts on the front of the camera.

Another multiple-exposure photograph, using a reflective base. A white backdrop was used in this case, but with a shadow cast at the top by black paper attached to the Hazylight, which was positioned above the subject. Two exposures were given, first a one minute exposure at $f/32$ to record the coloured lamps, then a single flash exposure at 6000 joules to light the subject. The requirement was for an overall darkish shot with a slight halo around the product and with the coloured lights reflected in the base.

to overdo it or the very dramatic, contrasty result will be completely lost and the picture will become rather dull.

One thing to bear in mind when using acrylic sheet is that the material tends to generate a lot of static electricity. Because of this it tends to attract rather a lot of dust to itself; particularly troublesome are the little white bubbles which break off sheets of expanded polystyrene used as reflectors. These themselves are also susceptible to static electricity, and so when they find their way on to the acrylic sheet they are very difficult to get rid of. For this reason it is a good idea to use an anti-static spray on the acrylic sheet to clean it. While this will not get rid of the static problem completely, it will at least ease it.

The other thing to watch with acrylic sheet is the possibility of scratching. When cleaning the sheet, take very great care and use only the softest of cloths with which to polish it. Because of the way the sheet is lit, every scratch and speck of dust will show up clearly in the finished picture.

White background and reflective base
A further development of the acrylic sheet as a reflective background or base is to use it in conjunction with a very bright white background. This type of arrangement is highly suitable for shots of products contained in bottles such as perfumes, wines, whisky and the like. There are two ways of achieving the result: directly and indirectly. The indirect method is the one to use if you do not have access to a fish-fryer light source. It consists of laying the acrylic sheet flat on the table as for the previous method and suspending a sheet of white paper on the wall behind it, and spaced 0.7 to 1 m behind it. A flash unit fitted with a fairly wide reflector is then placed beneath the level of the table so that it is directed upwards on to the paper. This gives a very bright background which emphasises the liquid in the bottle and is reflected in the acrylic sheet. The whole effect is one of crisp purity, giving the products a very desirable property.

A better way to create this effect, though, is to use the direct method. This once again calls for a fish-fryer light source. In this case, it is set up vertically behind the subject and the acrylic sheet is pushed right up to it. The effect is much the same as with the indirect method, with the very bright white background being reflected in the acrylic sheet and giving perfect transparency to the liquid in the bottle. However, because the background in this case is now formed by the large light source itself, the background becomes far more even and luminous so the result is even better.

Room sets
Building and photographing room sets in the studio is one of the most interesting and rewarding branches of photography. Interesting because it involves working in close co-operation with a designer to evolve an arrangement of furniture and furnishings that resembles a real room yet leaving enough space for the camera and lighting equipment so that the set can be photographed. Rewarding because when the final picture is seen, the photographer has the great satisfaction of knowing that he had complete control over every stage of the picture. He had to supervise the building of the set, its decoration, the laying of carpet if it is included in the picture, the arrangement of the furniture and the placing of the table lamps, magazines, plants and so on which make the set look as though it is a room actually used for living in. Then he had to set up the lighting, carefully balance it, and set up the camera. In fact, the actual exposing of the film to take the shot is almost an anti-climax at the end of perhaps two days of building and dressing the set.

The main thing to bear in mind when involved with room-set photography is to try to make the result as natural-looking as possible. Generally, this means that if there is a window included in the room set, the main proportion of the light should appear to be coming from this window and should be simply balanced with lower-power flash units inside to keep the subject brightness range within reasonable

limits. This way it is possible to create what appears to be a beautifully sunny room that would be a pleasure to live and work in.

Room sets are constructed from large sheets of chip-board or fibre-board held upright by battens and braces and fixed together with carpenters' clamps. If light is to be directed into the room through a window, these 'flats' as they are called must be positioned at least 0.7 to 1 m from the walls of the studio to allow access for both the flash unit and the photographer. Since the ceiling is rarely featured in room sets, the top of the set is usually left open. The flats are decorated with wallpaper or tiles, depending on the type of room the set is designed to simulate; the floor coverings in the form of carpets, wooden blocks or tiles are laid on the floor. In the case of floor tiles, these are simply placed in position but are not stuck to the floor and they extend only over the area which will be seen by the camera. Wall tiles are usually fixed in position with double-sided adhesive tape and are quickly grouted with a weak mixture of wall filler.

Ornaments, plants, books and the like are usually placed in the shot by the studio stylist, a person who is specially trained in this sort of work. A good stylist will look at a room set and immediately go and collect together a whole range of bits and pieces that will look right in the room, arranging them so that they add life to the room set yet retain a sort of casual elegance.

The main light source for the room set should be placed outside the window and can be either a large soft source unit known as a 'swimming pool' or a smaller unit bounced off a large sheet of white polystyrene. Inside the room set, the lighting may be controlled either by the use of more large sheets of white polystyrene or by another swimming pool or smaller units bounced off sheets of polystyrene. However, the power of these fill-in lights must be carefully controlled so that the interior of the room is not over-lit, otherwise the result looks totally false.

Room sets do not have to be large, complex arrangements portraying a whole room; they can be just a small set-up which simulates the corner of a room or an area along one wall. In this case, all that is needed is a pair of flats at right angles to form the corner of the room, decorated with wallpaper and the objects to be photographed placed within this area. When the objects are small items which are to be depicted as though on a table or sideboard against a wall, the two flats are placed side-by-side with a sheet of polished wood up against them, and the objects to be photographed are arranged on this piece of wood. To add interest to the shot, pictures or prints can be hung on the wall and other ornaments placed on the piece of wood. In this case the lighting would be from a single fish-fryer head, possibly supplemented by one or more white reflectors to add light to the front of the subject.

Food photography

Like room-set photography, this is a really specialised area which perhaps owes more to the careful preparation and arrangement of the food than to the taking of the actual photograph; this is borne out by the fact that the food-photography market is dominated by a handful of top professionals who know all the tricks of the trade and can produce an appetising picture of virtually any food product. Taking a good food photograph is really a team effort. First there is the art director who works for the advertising agency or magazine which has commissioned the picture. His contribution is to conceive the picture in the first place, using the product or theme of the cookery article as a starting point. He will have an idea of the picture fixed firmly in his mind and it is his job to brief the photographer on what is actually wanted.

Next, there is the home economist, who prepares the food and arranges it on the plates or in the dishes, making sure that it looks absolutely perfect. The garnish on a plate of steak and vegetables, for example, must be exactly the right texture and

Using the light source as a
background. In this shot the
background was a sheet of
opal acrylic with a flash
head behind it. This gave
transmitted light for the
glasses of coloured liquid,
and the black acrylic base
gave reflections.

An example of the use of a
black acrylic base with the
light source reflected in it.
Notice how the reflection of
the cassette recorder in the
pool of light is really deep.

All is not as it may seem! Not a real kitchen but a studio set. The walls are chipboard 'flats', the tiles attached by double-sided adhesive tape and the floor tiles simply laid without adhesive. The lighting was very simple: a large sheet of white polystyrene was placed at an angle outside the window, which was covered with opal acrylic sheet, and a Broncolor standard head directed at it from behind the flat. This provided the main 'sunlight' effect. A Hazylight at lower power was placed at the opposite side of the set to provide fill-in.

colour, the whipped cream on a portion of fruit pie must curl in exactly the right way, and a casserole must show succulent pieces of meat and vegetables emerging from the liquid.

Then there is the stylist. The job of this vital member of the team is to choose which plates, dishes, saucepans, cutlery, napkins, tablecloths and so on are used in the picture to complement the food perfectly. A good food studio will have an incredibly large stock of plates and other accessories for the stylist to choose from, and if what is wanted is not amongst this collection, the stylist will know exactly where to go to borrow, hire or buy it. The stylist will arrange all the components of the picture, leaving the photographer to make the final adjustments. She will also know where to buy the finest vegetables, meat, cheese, bread and so on to put in the shot.

Finally there is the photographer. Food photographers are almost without exception perfectionists willing to spend hours on a single shot to get everything just right to make a mouth-watering picture. The photographer's main problem is making sure that the food reproduces in its proper colours when printed in the magazines. Because subtle colours are often lost in the colour reproduction process, this often means reinforcing these subtle colours artificially – adding yellow dye to a cake being mixed in a bowl, for example.

For this reason, food photographers often buy their colour film in very large amounts to ensure that all the film for, say, six months' shooting is from the same manufacturing batch. When the new film arrives the photographer will carry out extensive tests on one box to establish exactly which, if any, filters are necessary to ensure a perfectly neutral colour balance. A very pale yellow or red filter is often necessary when using studio electronic flash to create this perfectly natural balance. He will then store the film in a deep freezer so that it will not change in colour balance over the period he is to use it.

The photographer will also spend quite a considerable time in final adjustments to the picture before shooting. He will, perhaps, put liquid paraffin on to sausages or chips to make them glisten better, or wipe lemon juice on freshly cut fruit to prevent it from turning brown. I remember working with one well-known food photographer who spent three-quarters of an hour with an artists' paint brush arranging crumbs on a plate from which a slice of cake had been cut!

The technical side of food photography (the arrangement of lighting and so on) is basically very simple. What is needed is a broad, soft light source positioned in such a way that the food being photographed glistens and looks appetising. What this calls for, is the fish-fryer or hazylight unit positioned above and slightly behind the subject to give top back lighting which will produce the required glisten in the shot. The camera is usually positioned so that it looks down on the food from about three-quarters front. This ensures that any highlights on the food produced by the slight back-lighting are picked up by the camera. The camera itself is usually a $12 \times 10\,cm$ or $24 \times 20\,cm$ studio camera to ensure that maximum detail and superbly crisp sharpness are retained in the picture.

Naturally, one of the prime requirements for a food studio is a well-equipped kitchen in which to prepare the food ready for photography. Often several dishes are prepared and cooked, sometimes in the case of casseroles with varying amounts of crumpled kitchen foil in the bottom of the casserole beneath the surface to plump up the meat, as it were, to give a more appetising look to the dish.

Then the actual dish to be photographed is chosen from those prepared immediately before the shot is taken. Quite often an empty saucepan or casserole is used to enable the photograph to be arranged while the food is being prepared, and at the last moment the empty utensil is removed and the one containing the food fresh from the oven is placed in the picture.

Shadowless lighting

One of the most notoriously difficult subjects to photograph well is silverware. Being shiny, it picks up reflections of the lighting, the camera, and various bits and pieces in the studio itself. But more than this, if a shiny object is lit directly with flash units or with any other artificial light source, instead of producing even-lighting effects on the object, extremely bright specular highlights are formed which do nothing at all for the product.

Fortunately, there is a fairly simple way to overcome this problem. Instead of lighting the subject directly with flash heads, build a 'tent' of white translucent material such as tracing-paper all around the subject. This means, of course, that all the reflections in the shiny object are now from the tracing paper. So instead of producing bright specular highlights, the effect is of flat white surfaces. The flash units to light the subject are placed outside this tent, one or more either side of it, and the camera looks into the tent through a small hole cut in the front. Lighting the subject in this way provides a completely even diffused light which illuminates every part of the subject equally with very soft delicate shadows cast on the base and the underparts of the subject.

An interesting variation on this technique is to build the light tent so that it surrounds only the front and two sides of the subject, leaving the back open. The subject can then be placed on a white table top and black background suspended behind the table and behind the light tent. This gives the effect of the subject being thrown into sharp contrast by the black background yet still being lit softly to avoid specular highlights in the shiny surfaces. If necessary a fairly low-power flash head fitted with a snoot to reduce the size of the light source can be directed on to the subject from the back of the set outside the field of view of the camera to provide a single specular highlight on the top edge of the subject, and this can be emphasised by using a cross-screen on the lens of the camera to give a star effect from this specular highlight.

Another variation of the light-tent technique is to fix one or more carefully-cut strips of black paper inside the tent so that they are reflected by the subject. This immediately adds depth to the subject because it breaks up the uniform white appearance of these shiny objects when lit by the light-tent method. Careful experimenting with the positions of these strips of black paper, though, must be carried out in order to find the most suitable positions for them. For example, if a small black reflection is required on each side of a silver cup, try to position the strips of black paper so that the reflections are at different distances in from the sides of the cup, otherwise the result will be too symmetrical and will tend to look contrived and artificial. Flat shiny objects can be given a degree of sparkle and depth by placing them on a black background, lighting by the tent method and shooting directly from above. This method is particularly successful if the object has a surface pattern or texture which is then emphasised by this method.

Shadowless background

While the white background limbo arrangement mentioned at the beginning of this chapter gives an even white background suitable for many product photographs, shadows, although very soft and delicate, are cast by the subject on to the background. Sometimes, though, a background totally free from all shadows is required and this again is achieved in a very simple way. Place the subject on a sheet of white opal acrylic material supported at either end, and light this from underneath with one or more flash heads.

Alternatively, place the subject on a fish-fryer or hazylight unit, the position of which has been adjusted so that the lighting surface is horizontal and facing upwards. The subject is now lit from above or to one side to produce the modelling required in it, but any shadows which would be cast by the object on to the background are completely overpowered by the light passing through the opal acrylic background.

Pages 120–121: a room set does not have to be complex. In this case it consists of a couple of strips of wallpaper on a 'flat' with a polished table pushed up to it and a few props to complement the subject.

Left: the classic graduated background. It is important to light the rear parts of the subject well to make them stand out from the dark part of the background.

Right: a multiple-exposure shot. First a 60-second exposure was given for the time on the digital clock (taking care to start the exposure just as the minute changed!). Next was a 3-second exposure for the picture on the television screen. Finally, a flash from a Hazylight, masked at the back to give a graduated background, was given. The TV screen was covered during the first 60-second exposure to prevent overexposure of the picture.

Silverware is notoriously difficult to photograph well. To produce virtually shadowless lighting for this shot, a large fish-fryer flash head was positioned above the subject and a curved white reflector round the front of the set. *Mason and Riley Marketing Ltd*. Taken by Ian Wren, Leicester. Art Direction by Alan Tyers, Three's Company Ltd., Birmingham.

A group of engine filters photographed on a graduated background. *Massey-Ferguson (UK) Ltd*., Art Direction by John Harlow, Three's Company Ltd., Birmingham. Photograph by Derek Watkins.

Careful positioning of the light source is essential for photographing reflective subjects. With uniform surfaces and a Hazylight head, it can be an advantage to reflect the light source in the subject.

One thing that needs special care when using this form of lighting is exposure determination. If a flash meter is being used to establish the correct exposure, it is most important to switch off the flash heads which are used beneath the opal acrylic to light the background. Only the light which is set to fall on the subject must be measured; the light positioned to shine through the background is there simply to burn out any shadows which would otherwise be formed, and if this is taken into account when making flash meter readings the result will be an underexposed picture. This type of lighting is particularly useful when photographing objects which have a delicate tracery of fine detail which would cast very confusing shadows if lit in the usual way. Used carefully, it can produce results of great beauty and delicacy.

Big power from small units

There are times in every studio when the flash equipment simply does not put out enough light to enable the use of an aperture small enough to give the required depth of field. In cases like this a technique is used for building up the exposure by giving several flashes. Naturally, the technique only works if the subject is totally stationary because if any movement takes place within the picture area between successive flashes the result will be a multiple image.

The system is quite simple to operate. Basically, it is necessary to double up the number of flashes for each stop smaller the aperture is set. For example, if the power of the flash unit calls for an aperture of $f/22$ and an aperture of $f/32$ must be used in order to create sufficient depth of field, the camera can be set at $f/32$ and two flashes given instead of one. If an aperture of $f/45$ is needed it would be necessary to give four flashes, if $f/64$ is required, eight flashes, and if $f/90$ is required, 16 flashes. However, it is not quite as simple as that. A phenomenon known as the intermittency effect means that one flash at, say, $f/22$ is more effective than 16 flashes at $f/90$. What this means is that a single exposure to a very bright light has more effect on the film emulsion than

several exposures to a less bright source of light. So in order to overcome this intermittency effect it is necessary to increase the number of flashes when working at smaller apertures.

If the camera is used at only one stop smaller than the flash is capable of exposing correctly, there is no need to increase the number of flashes above two. However, if an aperture two stops smaller is used, add one flash to the calculated four to give five flashes in total. At three stops smaller give two extra flashes to make a total of ten, and when working at four stops smaller give an extra four flashes plus one for luck to make a total of 21 flashes. It is not advisable to try to work at an aperture smaller than four stops below the working capability of the flash unit because each flash has such a small effect on the film that a large number of additional flashes are necessary to overcome the intermittency effect, and this makes the whole method rather unpredictable.

This chapter has been no more than an introduction to some of the many ways in which electronic flash can be used in the studio. There are, of course, many other methods of lighting subjects and of using flash for special techniques. Far too many, in fact, to go into detail here. The only limiting factor is the imagination of the photographer himself.

Flash and colour

On the face of it, there would seem to be little difference between taking flash photographs in black-and-white and taking flash photographs in colour. Up to a point, this is quite true; the problems of calculating correct exposure and positioning the flash are the same whether the film in the camera is a black-and-white one or a colour one. But there are certain techniques which can be used in colour photography which cannot be used in black-and-white, and there are a few additional problems with flash photography in colour.

Virtually all the problems encountered when taking flash photographs in colour are concerned with changes in the colour balance of the resulting colour picture. They are, of course, far more serious with colour reversal films producing slides or transparencies than with colour negative films from which colour prints are to be subsequently made. The reason for this is that changes in the colour balance can be corrected when making prints from negatives by changing the filtration at the printing stage, but with colour slides or transparencies, once the film has been exposed and processed there is little that can be done to correct a colour cast other than making duplicates from the original slide, and this almost inevitably leads to a loss in quality, however small. Even so, it is still better to correct the colour balance of a colour negative at the taking stage rather than at the printing stage, because this produces more consistent negatives which are easier to print and give better-quality prints. These problems of colour imbalance are all tied up with a phenomenon known as colour temperature.

Colour temperature
In one way, colour temperature is rather an unfortunate term. It is simply a way of defining the colour composition of a light source and could, perhaps, be better described as colour value, even

though temperature does come into it in a rather roundabout way. The light emitted by a lamp is said to have a colour temperature of 3200 K if the light is of the same colour composition as that of a perfect radiator heated to a temperature of 3200 K. Unfortunately, this perfect radiator is purely theoretical and does not exist at all, which only serves to complicate matters.

A further complication arises from the use of the particular temperature scale chosen to express colour temperature, the absolute temperature scale. This absolute temperature is based on a zero which is at −273°C; the lowest temperature theoretically possible. Temperatures on this scale are expressed in kelvins, in recognition of the work of physicist Lord Kelvin.

The colour temperature of a light source can also be expressed in mireds, which are easier to use for photographic purposes. Mired is a composite word made up from the words *micro-reciprocal degree*, and these words explain how the mired values are obtained. The colour temperature of a light source in mireds is equal to one million divided by the colour temperature in kelvins (which were originally called *degrees* Kelvin).

$$\text{Mired} = \frac{1\,000\,000}{K}$$

So a colour temperature of, for example, 5800 K has a mired value of

$$\frac{1\,000\,000}{5800} = 172.$$

Because of the way mired values are obtained – as micro-reciprocals of kelvins – the mired value decreases as the colour temperature in kelvins increases. So a colour temperature of 8000 K has a lower mired value than that of 5800 K; the mired value of 8000 K is 125.

The effect of colour temperature
Colour temperature affects colour photographs in a very significant way; it changes the colour balance of the picture. The human eye is a remarkable piece of optical equipment. Not only does it focus itself and adjust its aperture automatically to compensate for varying levels of illumination, it also corrects for colour temperature over quite a wide range. This means that, to the eye, an object which appears white in daylight also appears white in artificial light. Yet if an artificial light (tungsten) is switched on in a room into which daylight is also entering it will be seen immediately that the colour of the artificial light is very yellow compared with that of the daylight. Unfortunately, colour films are not nearly so adaptable; they see colour the way it really is, not the way we would like it to be. If a colour film is exposed to light of a different colour temperature from that for which it is balanced, there will be an overall change in the balance of the colour reproduction.

Colour films fall into two basic types, those designed for use in daylight and those for use in artificial light. When a film manufacturer designs a colour film, he makes the speeds of the three emulsion layers the same to the correct lighting colour temperature. A daylight-colour film has its three emulsion layers at the same effective speed when it is exposed to daylight within about two hours of noon. If a daylight film is exposed to artificial light (Photoflood or similar) which is yellower or redder than daylight, the balance will be upset. The effective speed of the red-sensitive layer which produces a cyan image in the finished picture increases, while the speed of the blue-sensitive layer producing a yellow image decreases.

This means that, after processing a slide film, the cyan image will be low in density while the yellow image will be too dense, giving a reddish-orange bias to the whole picture. The opposite effect results if a film designed for use in artificial light is exposed to daylight. The blue-sensitive layer will increase its effective speed while the red-sensitive layer will become effectively slower and the result will be a slide with a pronounced blue cast.

Page 128: if a coloured background is to be used, make sure it complements the subject well. *Bowens Sales and Service Ltd.*

Page 129: a single brolly flash was used for this photograph of a colour darkroom.

The colour temperature for which a daylight colour film is balanced averages around 5500°K (182 mireds) while films designed for use in artificial light are balanced for a colour temperature of either 3400°K (294 mireds) or 3200°K (313 mireds). The former are usully known as Type A films while the latter are known as Type B or Type L films and are designed primarily for professional use in studios equipped with tungsten lighting. Type A films are balanced for Photoflood lighting and are therefore more suitable for amateur use.

Flash and colour temperature

As was explained right at the beginning of this book, there are two basic types of flash, electronic and bulb. There are also two types of bulb, clear and blue-lacquered. Both electronic flash and blue flash bulbs have a colour temperature of between 5500 and 6000°K (182–166 mireds). This means that they are suitable for use with colour films balanced for daylight which includes all Type D, Type T and Type S films. However, if these types of flash are used with films balanced for artificial light, the resulting picture will have a strong blue cast. Clear flash bulbs present rather more of a problem. They have a colour temperature of 3800°K (263 mireds) and so are quite different from the colour balance of both daylight and artificial-light films. If they are used with daylight films they produce a fairly strong yellowish-red cast, and if used with artificial-light films they produce a bluish cast. Fortunately, though, this does not mean that flash cannot be used with colour films balanced for a colour temperature different from that of the flash unit.

Filters for colour

The difference between the colour temperature in mireds of a light source and that of the film being used is called the mired shift. Ideally, for completely neutral results, this mired shift should always be zero. So to balance the light source to the film, this mired shift must be reduced to zero or as close to zero as possible by using colour-temperature correction filters. To achieve this, the filter must be of the same mired value but opposite in colour to the mired shift.

Colour-temperature correction filters are available in two colours: reddish-brown to raise the mired value and lower the colour temperature of the light entering the camera, and bluish to lower the mired value and raise the colour temperature. They are usually available in four strengths, 15, 30, 60 and 120 mireds, and are coded with a prefix letter R or B to indicate the colour. Some manufacturers give the strengths of their filters in decamireds (tens of mireds) and in this case the filters are numbered 1½, 3, 6, and 12 respectively. There are still others such as Kodak and Hoya who use apparently aribitrary codings for their filters; they are shown in the table below.

Mired shifts with Kodak-type filters

reddish filters	mired shift	exposure increase in stops
81	+9½	⅓
81A	+18½	⅓
81B	+27	⅓
81C	+35	⅓
81D	+42	⅔
81EF	+53	⅔
85C	+81	⅓
85	+112	⅔
85B	+131	⅔
bluish filters		
82	−10½	⅓
82A	−21	⅓
82B	−32½	⅔
82C	−44½	⅔
80D	−56	⅓
80C	−81	1
80B	−112	1⅔
80A	−131	2

Now, assuming that the film being used is a Type L colour slide film balanced for a colour temperature of 3200°K (313 mireds) and the light source is an electronic flash unit with a colour temperature of

5500°K (182 mireds), this will normally produce, as just explained, a strong blue cast on the finished colour slide. So a colour-temperature correction filter must be used to prevent this. Subtract the colour temperature of the light source from that for which the film is balanced and this will indicate both the density and the colour of the correction filter required.

$$313 - 182 = 131$$

so the filter needed in this case is 131 mireds and the fact that the number is a positive one indicates that the colour of the filter should be reddish. The nearest standard filter to 131 is an R120 unless Kodak-type filters are being used in which case the No. 85B is exactly 131 mireds.

Here is another example. Assume this time that the film is a daylight one and the light source is a clear flash bulb. The film is balanced for a colour temperature of 5500°K (182 mireds) and the clear flash bulb has a colour temperature of 3800°K (263 mireds). Once again subtract the colour temperature of the light source from that for which the film is balanced.

$$182 - 263 = -81$$

so in this case the necessary filter will have a value of 81 mireds, and the fact that it is a negative number indicates that the filter should be bluish in colour. The closest standard filter to this is a B60 although a B60 and a B30 can be used together to give B90 which will rather over-correct the colour balance. But this may be preferable as the B60 used on its own will leave a slight blue cast which is less acceptable than the very slight reddish cast produced by the B90. Once again, if Kodak-type filters are being used the No. 80C is exactly −81 mireds.

Like many other filters, colour-temperature filters absorb a certain amount of light and so need a slight exposure increase to compensate. The actual amount of this increase depends on the filter and is given in the table above. Even when the colour

temperature of an electronic flash unit matches that for which the colour film is balanced, a slight blue cast sometimes appears in the slide. This is caused by the presence of ultra-violet radiation which the eye cannot see. Unfortunately, the colour film sensitivity extends beyond that of the eye so the film sees this ultra-violet radiation as blue. The result is rather similar to that produced on pictures taken in bright sunshine in the mountains.

Most modern electronic flash units emit a small amount of ultra-violet radiation, although the tube is often coated with UV-absorbing layer to minimise this. However, most older electronic units do not have this coating and tend to emit rather a large amount of UV. This can be counteracted by using a UV filter on the camera lens or, preferably, taped to the front of the flash unit. An even better solution is to use a very weak-yellow filter. The type of colour-compensating (CC) filter used for making colour prints is ideal for this and the value to choose is either CC05Y or CC10Y, depending on the amount of blue produced in the picture. But if colour-printing filters (CP rather than CC) are used, do not fit them to the camera lens as they may cause a loss in quality. CP filters are made from acetate rather than gelatine and are designed to be used in the enlarger above the negative so that they are not in the image-forming beam of light. These filters will have virtually no effect on the light output of the unit and can therefore be left in place permanently.

With the introduction in recent years of system flash units, many manufacturers are now supplying filter attachments to fit on to their flashguns. Among the range of filters available for these attachments is usually an ultra-violet filter to eliminate excessive blue in the pictures, and an 85B filter which corrects the colour temperature of the flash to match that of colour film balanced for artificial light. Since most of these system flash units are computer-controlled, they automatically take into account the density of the filter when controlling the flash to give correct exposure.

Reciprocity failure

The problems of reciprocity failure are normally associated with long exposures but they can be equally troublesome with very short exposures such as those given by computer-controlled flash units used at very close range or with very fast films. In theory, a film exposed for eight seconds at $f/16$ should produce an image of the same density as a frame exposed for ¼ second at $f/2.8$. This is called the Reciprocity Law of Bunsen and Roscoe. Unfortunately, though, photographic materials tend to be less sensitive to low levels of light than they are to high levels and the exposure has to be increased over the theoretically correct one in order to produce a satisfactory image. This is known as reciprocity failure. In fact, to produce a correctly-exposed image in the example above, the exposure time at $f/16$ would need to be not eight but 16 seconds with negative films, or 13 seconds with reversal film.

A similar thing happens with very short exposures, i.e. shorter than about 1/1000 second. Now, many computer-controlled flash units give exposures of around 1/15 000 second or even shorter when used at very close range and this can cause underexposure in the pictures. This reciprocity failure problem is fairly straightforward with black-and-white materials, but it is complicated in colour photography by the fact that colour films, instead of having just one layer of emulsion on the film base, have three selectively sensitised layers to record blue, green and red light respectively. These three layers have slightly different sensitivities and this means that the reciprocity failure effect is different in each of the three layers. This in turn means that not only is the picture underexposed if reciprocity failure is not taken into account, but it also suffers a shift in colour balance. In fact this shift is present even when reciprocity failure is corrected in terms of exposure. The colour of this shift is generally bluish and it can be corrected by using a CC05Y or CC10Y filter on the camera lens. To correct for reciprocity failure exposure-wise, open the lens aperture by half a stop.

Bounced flash and colour

Another colour cast problem which often raises its head when using flash with colour films is when the flash is bounced from a reflector to soften its quality. With black-and-white films it matters little what colour the reflector is as long as it is light-toned to reflect the maximum amount of light.

But when using colour film the colour of the reflector is most important, because when the light is reflected it takes on the colour of the reflector. So if a portrait is being taken by bounced flash and the wall or ceiling from which the flash is bounced happens to be light-green, your model will be bathed in a delicate pea-green light which, to say the least, is not very flattering!

For this reason, reflectors used for bounced flash with colour films should be white or very pale cream in colour; in fact the use of a cream reflector adds a slight warmth to the light which can be very flattering when shooting portraits. The same applies when using direct flash in a small room with coloured walls. Any light reflected from the walls takes on their colour and can cause a colour shift in the picture. A piece of black card placed alongside the flash unit to prevent the light from hitting the wall can go a long way towards curing this problem. Likewise, if a coloured background is being used it should be placed well back from the subject and if possible lit by a separate flash unit. A distance of at least the same as that between the camera and the subject is recommended for the best results.

Fitting the filter to the flash unit as opposed to the camera also enables flash to be used for fill-in when shooting on artificial-light colour film indoors. This means that a portrait, for example, can be taken by tungsten lighting as the main modelling light and a low-power fill-in flash with an 85B filter in front of it used to relieve the shadows without destroying the basic character of the lighting; the advantage is that the photograph still looks as though it was taken by available light.

Contrast and colour

One of the major differences between taking photographs on black-and-white film and taking photographs on colour film (especially colour slide film) is that black-and-white film handles a far larger subject brightness range than does colour film. While a black-and-white film will record plenty of detail over a subject-brightness range of between 5 and 10 to 1, a colour film will only handle a subject-brightness range of 2 or 3 to 1. For this reason it is important to pay great attention to the positioning of the various flash units when using multiple flash, and even when using a single flash it is advisable to use one or more white reflectors to throw a little light back into the shadows to relieve them a little.

Coloured flash

One of the techniques made possible by the introduction of filters for system flash units is to illuminate the subject with coloured light. This can produce results ranging from creatively unusual to bizarre, depending on how the technique is handled. It is quite easy, for example, to create the atmosphere of a night club by using a red filter on the main flash unit and perhaps filling-in with a small amount of unfiltered flash. This is sufficient to produce natural colours in at least part of the picture while retaining the dimly-lit mood of the night club given by the red filtered main flash unit. Similarly, it is possible to create the mood of an outdoor night shot by using a blue filter on the flash unit again, possibly, relieved by unfiltered fill-in light to key the picture to natural tones, as it were.

An even more interesting effect can be achieved by using two filters, one on the camera and the other, the complementary of the first, on the flash unit. This produces a background with a fairly strong colour cast on it with the main subject standing out in its natural colours. For example, if an orange filter is fitted to the camera lens and the photograph taken, the entire image will have a strong orange cast. But if a blue filter – blue being the complementary of orange and yellow – is fitted on

the flashgun and synchronised to the camera to light the subject in the foreground, the blue light from the flash unit will counteract the effect of the orange filter on the foreground to give natural reproduction, while the background remains strongly orange.

The technique for taking this type of picture is fairly straightforward. First of all, a suitable background must be chosen. The sky makes a very good background and so does a fairly contrasty subject such as winter trees silhouetted against the sky. In order to produce well-saturated colours in the sky the exposure needs to be kept to the minimum, so take an exposure-meter reading from the sky, and if a separate hand-held meter is being used, do not forget to allow for the filter factor or the sky will be far too underexposed.

Next, fix the complementary filter to the flash unit either with adhesive tape or, if the flash unit has a filter attachment, in the holder for this attachment. Using the flash filter factor, calculate the distance at which the flash should be placed for an aperture one stop smaller than is actually being used on the camera. In other words, if the exposure for the sky is 1/60 second at $f/11$, calculate the flash distance for an aperture of $f/16$. This will put the flash unit closer to the subject and will mean, in fact, that the subject will receive twice the amount of light normally required for an aperture of $f/11$. The reason for this is to compensate for the light absorbed by the two complementary filters – one on the camera and the other on the flash unit. This will provide a good starting point for individual experiments to adjust the relative exposures for the background and the foreground. For the first few shots it is worth bracketing the exposure and flash distance to find out which combination gives the best results. But be sure to keep careful notes so that the experimenting is not necessary for future shots.

If something a little more bizarre is required, try setting up two flash units, one either side of the

Many system flashguns have sets of filters to enable coloured lighting to be produced. This one is by Sunpak.

subject, and placing a different-coloured filter in front of each. The subject will cast a shadow in each direction which will then be filled in by light of a different colour. For example, if the flash unit on the right of the subject is covered by a red filter and that on the left by a green one, the shadow cast to the left of the subject by the red-filtered flash will be green. And the shadow cast to the right by the green-filtered flash will be red. By varying the distances of the two flash units it is possible to create a wide range of different effects.

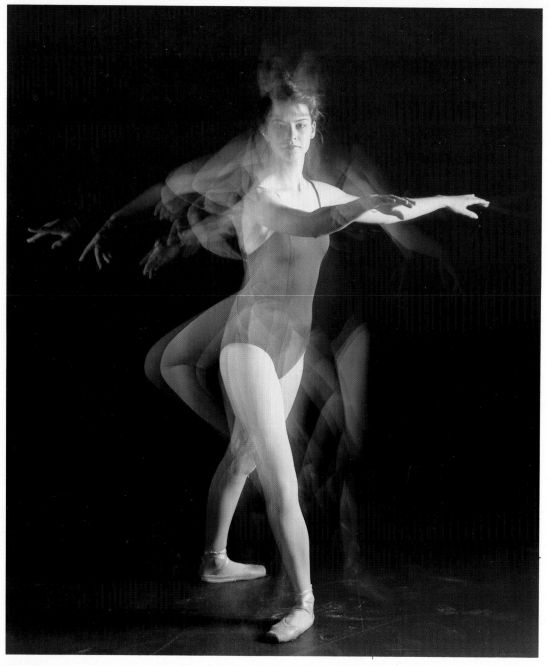

Left: a multiple flash technique can add interest to pictures of action subjects. *Philips Ltd.*

Right: the exposure for this picture was calculated so that four flashes were necessary, then one flash was given with the box lid in each of four positions. *Massey-Ferguson (UK) Ltd.* Art direction by John Harlow, Three's Company Ltd., Birmingham. Photograph by Derek Watkins.

Special techniques

In order to complete a book on the use of flash in photography there are a few rather specialised techniques which must be mentioned, such as using flash for close-ups, triggering the flash by sound and breaking a light beam, and so on. Because the techniques are so specialised they are dealt with only briefly here, though in sufficient detail to enable the photographer to use them. If more information is required, there are several specialist books on the market which give it.

Flash for close-ups

Electronic flash forms the most suitable source of lighting for photographing close-up subjects indoors. Because it produces a very bright and extremely short burst of light it will freeze any movement in the subject, even if the subject is something like a very agitated insect; and because the flash of light is so bright it enables a very small aperture to be used to give maximum depth of field. Tungsten lighting, while sufficiently bright to enable a reasonably small aperture to be used, has the disadvantage of generating rather a lot of heat which, if used close to a delicate subject, such as a flower, can cause it to wilt. And if the subject is an insect, tungsten can easily do irreparable harm.

If small studio-flash units are being used for close-up work, the modelling lamps – which are not bright enough or hot enough to cause damage to the subject – can be switched on to give a visual indication of the lighting which will be produced by the flash. However, if a small portable unit without a modelling lamp is being used, the best position for it is slightly to one side and slightly above the camera so that the light hits the subject from an angle of about 45°. Place a small white reflector on the other side of the camera to lighten the shadows, and the lighting will be suitable for just about any close-up subject.

Exposure for close-ups

The biggest problem of all when using flash for close-up photography is the determination of correct exposure. The problem arises because when the camera is used at very close quarters, the distance between the lens and the film plane is far greater than it is when focused at infinity in order to be able to reproduce a sharp image of the subject on the film. Now when the distance between the lens and the film plane is increased by a large amount, the aperture scale engraved on the lens is no longer accurate; the effective aperture is considerably smaller than the marked aperture. In fact, when the camera is focused to produce an image on the film the same size as the subject, the aperture markings on the lens are two stops out. For example, when the camera lens is set to $f/5.6$ the effective aperture is $f/11$.

From this it is obvious that the guide number quoted for the flash unit will no longer apply when extension tubes or bellows are used on the camera to enable it to be focused at very close distances. Fortunately, there is a fairly simple formula which can be used to calculate the correct aperture to use for the flash when shooting close-ups, as long as the reproduction ratio is known.

$$A = \frac{N}{D(M + 1)}$$

where A = aperture required
D = flash-to-subject distance
N = guide number for normal use
M = reproduction ratio.

For example, if the flash unit has a guide number of 30 and it is being used at a distance of 0.6 m from the subject with a reproduction ratio of 2 : 1 (i.e. the image on the film is twice the size of the subject), the required aperture will be:

$$A = \frac{30}{0.6(2 + 1)}$$

$$= \frac{30}{1.8} = 16.67 = f/16 \text{ approx.}$$

Alternatively, if the reproduction ratio is known and the necessary aperture to give the required depth of field is also known, the correct distance for the flash unit can be calculated by transposing the formula above to:

$$D = \frac{N}{A(M + 1)}$$

So if the guide number of the flash unit is 15 and the reproduction ratio is again 2 : 1, but the aperture to be used is $f/16$, the correct distance for the flash unit will be:

$$D = \frac{15}{16(2 + 1)}$$

$$= \frac{15}{48} = 0.31 \text{ m}$$

Now all this is rather a long-winded procedure to have to go through each time a close-up shot is to be taken, so to avoid this, use the chart reproduced opposite.

To find out the correct distance, simply place a straight edge so that it passes through both the guide number on scale B and the reproduction ratio on scale C, and then read off the correct flash distance on scale A. The chart has been designed for use at $f/16$ since this is the smallest aperture on many 35 mm cameras and is a reasonably small aperture to use on other types of camera. However, the chart can be used with other apertures if required as long as the flash distances determined on scale A are modified. If, for example, it is required to use an aperture of $f/8$ instead of $f/16$, the distances on scale A must be doubled, while if an aperture of $f/32$ is required the distances must be halved.

The following is a rough and ready method of calculating the correct exposure for close-ups when shooting black-and-white or colour negative films, which have more latitude than colour slide film. When the camera-to-subject distance is more than about 1.3 m, calculate the required aperture from

Chart for calculating flash distance for close-up photographs taken at $f/16$. Place a straight edge through the flash guide number on scale B and the reproduction ratio on scale C. Then read the flash distance on scale A.

flash
distance
cm

flash
guide
number

reproduction
ratio

A

250
230
200
180
150
125
100
75
50
25
23
20
18
15
12·5
10
7·5
5

B

60
45
30
24
18
15
9
6

C

10:1
8:1
6:1
5:1
4:1
3:1
2:1
1:1
1:2
1:3
1:5
1:10

the guide number and distance in the normal way. When the camera-to-subject distance is about 0.6 m, calculate the aperture required from the guide number and distance but open the lens aperture by half a stop. At a camera-to-subject distance of 0.3 m, open the lens by one stop, and at distances closer than this open the lens aperture by 1½ to two stops. But at these very close distances it is worth bracketing the exposure by half a stop and one stop under- and overexposure to be sure of acceptable results.

Computer flash units can also be used for close-up work, but in this case the aperture scale on the flash unit must be set to a different value from that on the camera. For example, when the camera-to-subject distance is 0.3 m, if the lens aperture is set to *f*/11 the aperture scale on the flash unit must be set at *f*/16; this will then give the same effect as opening the lens aperture on the camera by one stop.

Ring flash for close-ups
A ring flash unit is a special electronic flashgun which has a circular flash tube in a circular reflector and is fitted to the camera around the lens, rather like a lens hood. The ring flash head is connected to a power pack supplied with the unit or, in some cases, it may be connected to a power pack from a different manufacturer which the photographer may already have. At least one manufacturer of single-lens reflex cameras, Nikon, produces a special close-up lens which has a ring flash unit built into it so the flash head and lens form a single unit. This special unit is called the Medical Nikkor.

The idea of the ring flash unit is to provide perfectly-even frontal illumination for close-up work and especially medical subjects. They are particularly suitable for photographing subjects which are rather inaccessible through being within a confined space which prevents light from a conventional flash unit from penetrating to illuminate the subject. It is also suitable for producing even illumination on small subjects to be

photographed in close-up (such as stamps and the like), because it provides equal light levels from all directions on to the subject. While the ring flash unit is quite useful for this type of photography, it is an expensive luxury if used only infrequently. An effect similar to that produced by a ring flash is given by using two or more small flash units fairly close to the camera lens, one either side. If four units are used, locate one either side, one above and one below the lens. This arrangement is suitable for all but the most tricky of ring-flash applications where the subject is located within a very confined space.

Flash for copying

A similar requirement to ring flash is necessary when copying flat originals such as paintings or drawings. The lighting must be completely even all over the original to avoid variations in tone on the finished print or slide. To produce this perfectly-even illumination, two flash units are required, one either side of the camera lens. They should be positioned so that they are on the same level as the lens but well to each side so that the light falls on the subject from an angle of 45°. This ensures not only even illumination, but it also eliminates any reflections of the light sources in the subject if it has a shiny surface – a drawing or painting behind glass, for example.

The correct exposure to use when copying by this method is calculated in the same way as explained in the chapter on 'Flash and exposure' for multiple flash. Find the equivalent guide number for the two individual flash units used together from the formula

$$N_e = \sqrt{N_1{}^2 + N_2{}^2}$$

then use this equivalent guide number to calculate the correct aperture to use for the distance between the subject and one of the flash units. So if both units have guide numbers of 15, the equivalent guide number for the two will be

$$N_e = \sqrt{15^2 + 15^2} = 21$$

Ring flash is suitable for shadowless close-up lighting. The unit fits around the camera lens and is powered by a separate power pack.

If the two flash units are each 1 m from the original being copied, the correct aperture to use will be approximately $f/22$.

Infra-red flash

Taking photographs without the subject being aware of being photographed has always interested a great many photographers. With modern high-speed films it is possible to shoot candid pictures in conditions of very low levels of available

Extension bellows were used with a 35 mm camera to photograph this moth. Lighting was provided by a single flash.

light; situations which only a few years ago would have been thought to be impossible. However, there are times when it is necessary to reinforce the available light in order to get an acceptable picture, but with normal films and flash units this would immediately betray the presence of the photographer. But by using special film sensitive to infra-red radiation in combination with a filter which transmits infra-red but absorbs all visible light, it is possible to use flash to reinforce the available lighting. The filter required for this purpose is a Kodak Wratten No 87 filter which is available in gelatine. Fix it to the front of the flash

unit with adhesive tape so that it completely covers the front of the flash head where the light emerges. This enables the flash unit to be used in conjunction with special infra-red film, such as Kodak IR, without subjects being aware that supplementary lighting is being used, or indeed, that a photograph has been taken. Since the infra-red output of flash units varies considerably it is not possible to give any guidance on exposure or guide numbers suitable for use with this method. Instead, the photographer must carry out tests with his own equipment and use the results of these tests as a basis for calculating correct exposure.

Sound-triggered flash

Earlier in the book we looked at triggering a flash unit remotely by connecting a slave unit to it which responds to a brief flash of light. In this way, several units can be fired at any one time but with only one of them connected to the synchronising lead of the camera, or alternatively a single unit can be fired remotely by flashing a pencil torch at the slave unit which controls it. This idea can be extended to cover triggering by other means, a common one being sound. Sound triggering enables photographs to be taken which need split-second timing far faster than human reactions are capable of, e.g. a balloon being exploded by a dart or the splash of a drop of water falling into a bowl of water. What happens is that a transducer in the form of a small microphone or loudspeaker picks up the sound pulse generated by the exploding balloon or falling water drop, converts it into an electrical pulse which is then amplified and used to trigger a silicon-controlled rectifier, or SCR, which in turn closes the synchronising circuit and fires the flash unit.

Because electronic circuits work at a speed approaching that of light, there is no significant delay between the sound arriving at the pick-up microphone and the flash being fired. There is, though, a tiny delay between the sound being produced and being picked up by the microphone. This is because sound travels much slower than light and so there is a slight delay which varies according to the distance of the pick-up microphone from the subject generating the sound. This, however, is very much an advantage because it enables the firing of the flash to be fine-tuned to suit the individual requirements of the shot. In other words, it enables the photographer to decide whether he wants to capture the subject immediately after the action which produced the sound (for example the balloon bursting as the dart pierces it) or a few micro-seconds afterwards when the balloon has started to collapse. Naturally, a great deal of testing must be carried out in order to find out the effects of moving the microphone

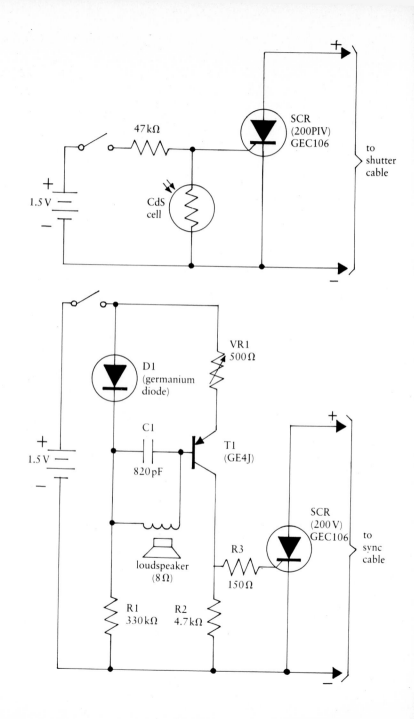

The circuit and its operation are both very simple. Basically, what happens is that a voltage-divider circuit made up from a resistor and a cadmium sulphide (CdS) photo-cell is connected to the control electrode of a silicon-controlled rectifier (SCR). When the beam of light is shining on the CdS cell its resistance is low. The voltage at the junction of the fixed resistor and the CdS cell, and hence at the control electrode of the SCR, is also low; lower, in fact, than is necessary to trigger the SCR. Now, when the beam of light is broken, the resistance of the CdS cell rises and with it the voltage being fed to the control electrode of the SCR. This causes the SCR to trigger, closing the synchronising circuit and triggering the flash. A slightly more complex circuit can be used which enables the sensitivity of the circuit to be adjusted by turning a small control-potentiometer.

The triggering circuits for both sound and interrupted light beam given in this chapter are both simple and inexpensive to build. It is also possible to purchase ready-built radio-control devices which enable the flash to be triggered from a considerable distance by a radio signal. Some of these units are attached to the camera so that a radio signal is transmitted when the shutter release is pressed. Others consist of a small radio receiver which is connected to a motor drive unit on the camera which fires the shutter release and the flash unit when a radio signal is transmitted from a separate unit at a considerable distance from the camera. This system also enables several pictures to be taken one after another without the photographer approaching the camera between shots, the motor-drive units both firing the shutter and winding on the film after the shot has been taken.

These units are available from some photographic manufacturers, but those readers who have an interest in electronics can often find suitable circuits published in model makers' radio control magazines and handbooks which are available from model stores and many booksellers.

A special 'Action Maker' lens attachment was used to simulate movement. A single flash on the camera provided the lighting.

Above left: a circuit for a sound-operated flash synchroniser. The flash fires when a sound is picked up by the loudspeaker. Below left: this circuit triggers the flash unit when a beam of light shining on the CdS cell is interrupted.

closer to or further away from the subject; but if careful notes are taken, this information will prove invaluable for future shots of this type.

Interrupted light beam

Flash photographs are often taken by slave units which respond to a pulse of light. A less common but equally useful system, however, is to trigger the flash by breaking a beam of light directed on to a slave unit by a small torch or other small lamp. This system is often used by natural-history photographers to shoot pictures of wild animals or birds; in fact the subject photographs itself! The light and slave unit are set up on either side of a known track used by the animal or on the known flight-path of the bird, with the camera focused on a point in the middle of the beam. When the animal or bird, following its normal habits, breaks the beam of light, the flash fires and the photograph is taken.

Index